I Am Rich Potosí,
Treasure of the World,
King of the Mountains,
Envy of Kings.

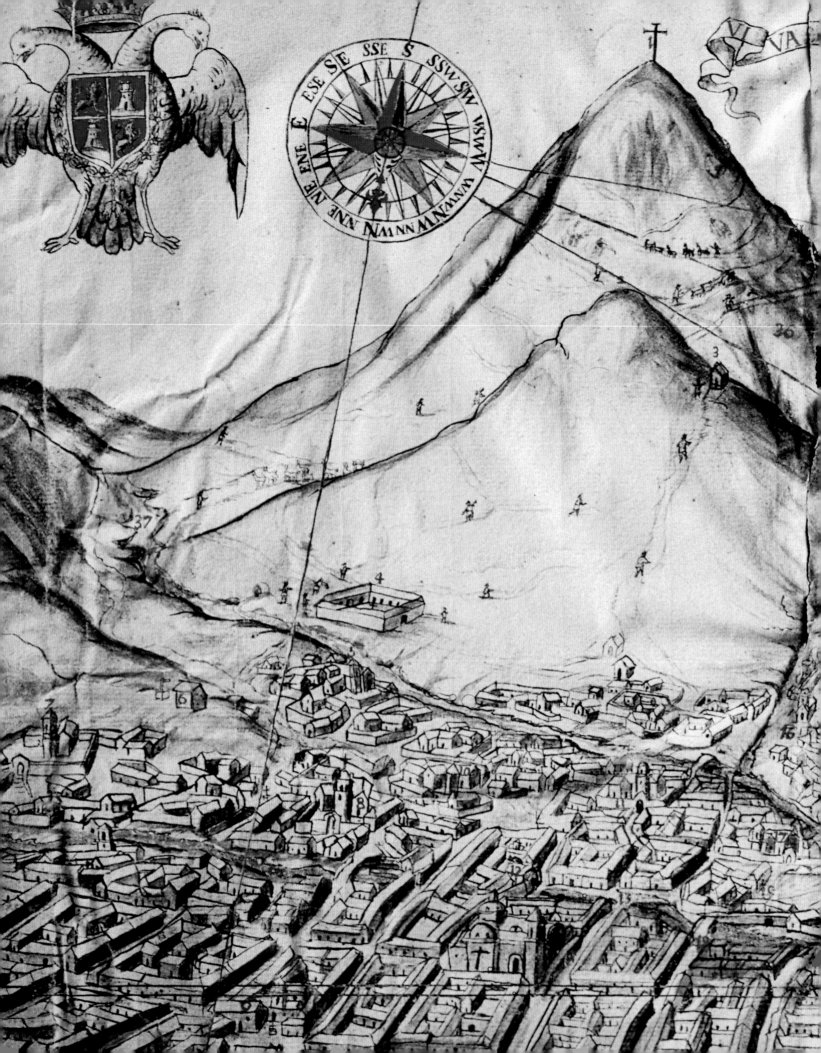

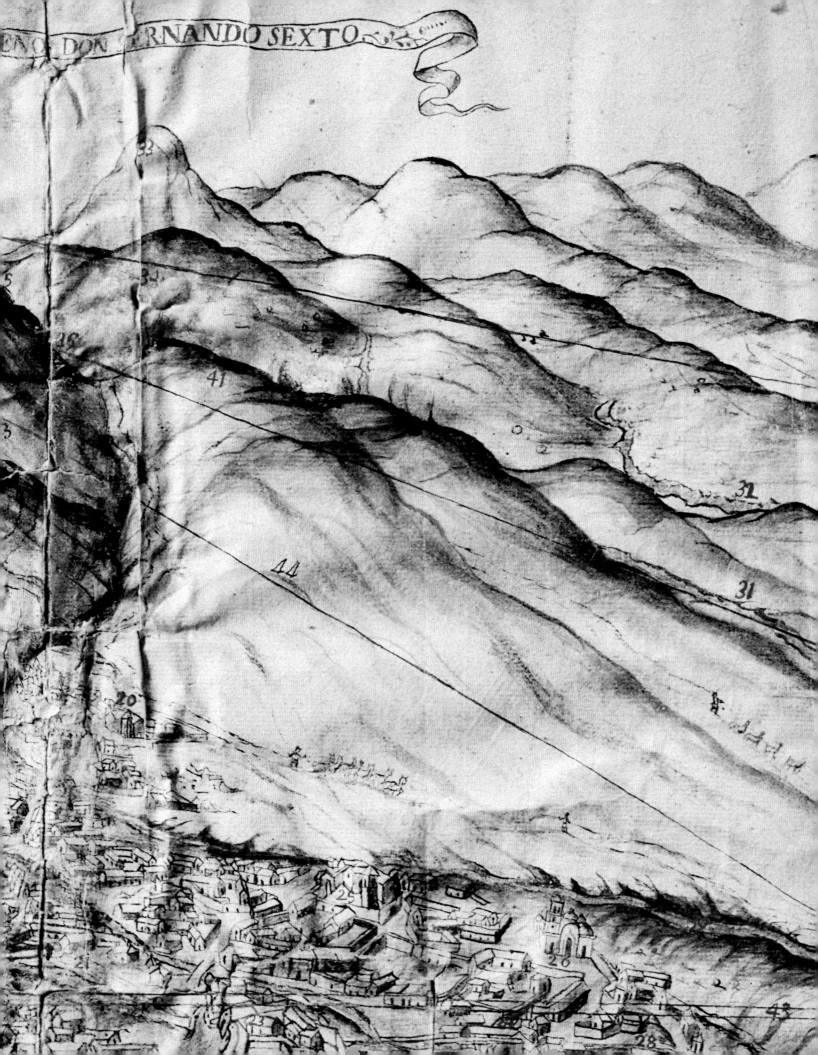

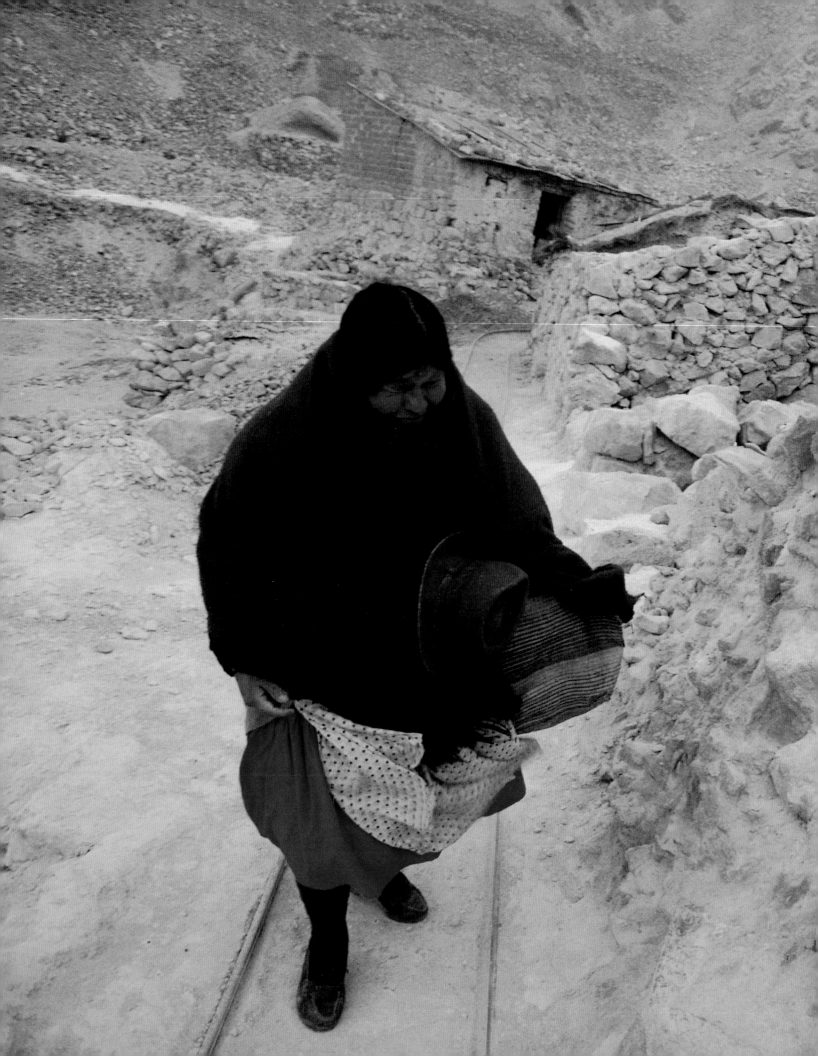

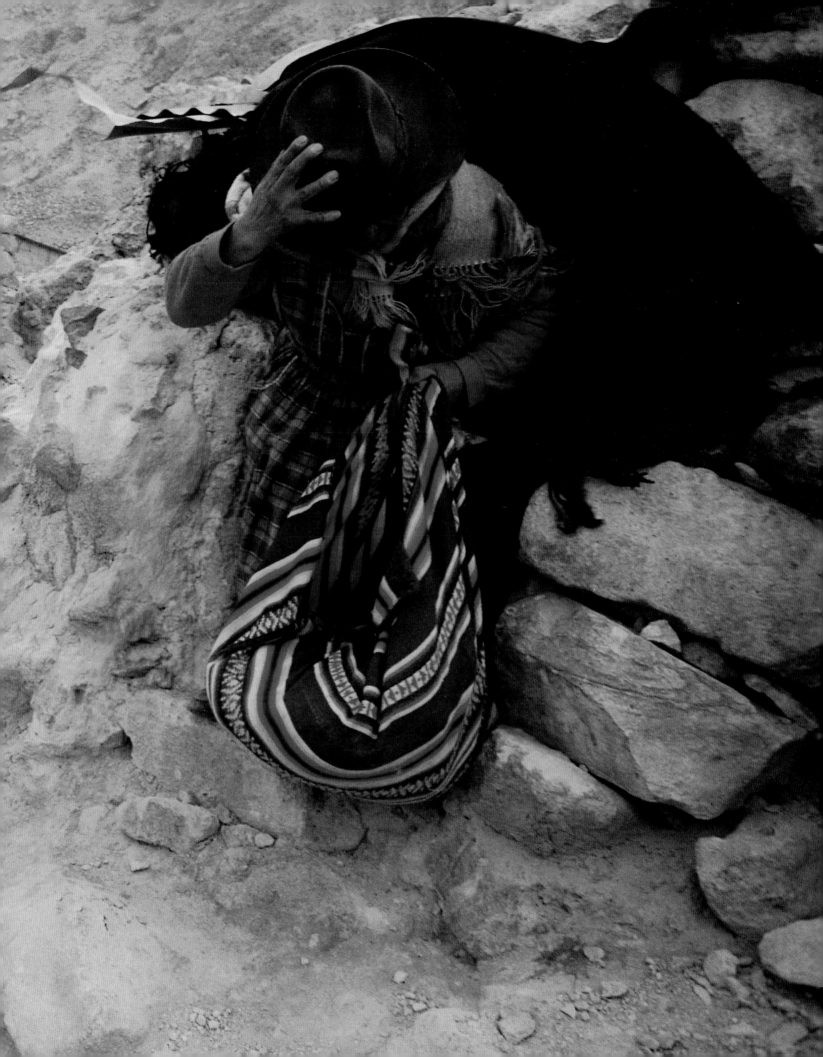

I Am Rich Potosí

The Mountain That Eats Men

Stephen Ferry

The Monacelli Press

This book would not exist without the collaboration of many people in Potosí, who gave me access to their homes and places of work, talked to me at length of their experiences, and offered me their friendship. My *comadres,* Valentina Puita Contreras and Sinforosa Fita Morales (whose image appears on the cover), helped me to feel at home. Jorge Gutierrez provided invaluable assistance as a translator from Quechua and source of contacts. I am very grateful to Mario Bravo, now of the Porvenir section, and the leadership of the Rosario Bajo, Candelaria Baja, and Caracoles sections of the Unificada Cooperative. Many thanks also to the extended family of Jonny Alvarez; Luisa Asama Viuda de Mamani; Roberto Carnaghi; Dulfredo Durán, president of the Association of Retired Miners; Antonio Flores; Nancy Herredia; Bernabé Mamani; Santos Mamani; Oscar Medinaceli; Wilson Mendietta Pacheco, director of the Casa de Moneda Museum; Justina Parra de Cortes; Abel Ricaldi; Iber Tapia and the Hostal Colonial; Dr. Julia Valdivia, head of the Lung Disease Section of the Caja Nacional Hospital; and the leadership of the Association of Palliris.

I am so grateful to my parents, Anne and David Ferry, for their love and enthusiasm, their invaluable help with editing and research, and, above all, their example; and to my sister, Elizabeth Ferry, who as a fellow student of Latin America encouraged me and showed me new ways of understanding the issues of historical legacy and patrimony.

Alma Guillermoprieto believed in this project from the beginning; the influence of her journalistic rigor and deep understanding of Latin America is felt on every page. I owe a huge debt to Alison Morley, who brought her amazing eye and knowledge of photography to bear on the editing. Susan Meiselas has been an important source of inspiration and advice, and also of well-placed kicks. Suzanne Pace turned my subconscious toward Bolivia and has been supportive ever since. Eduardo Galeano's book *The Open Veins of Latin America* first taught me about Potosí, and I am honored to include his writing in this volume. I am very fortunate to have learned from Bob Dannin, Arthur Gold, and Eido Shimano Roshi; these wonderful teachers gave me the preparation and guidance I needed to do this work.

I am also most grateful to Ruth Eichhorn of *Geo* magazine for her early support and for the kindness she showed to Luisa Asama Viuda de Mamani; and thanks to Christiane Breustedt, also of *Geo*. Likewise, I appreciate the support of *Natural History* magazine and its editor, Bruce Stutz, and also the excellent reporting by Marguerite Holloway for *Natural History*. Gamma Presse Images backed this work in its earliest stages, and for that I am particularly thankful to Floris de Bonneville. I am fortunate to have the support of the editorial staff at Gamma-Liaison, particularly Donna-Marie Barnes, Michel Bernard, Susan Carolonza, Sandy Ciric, Jennifer Coley, and Valerie Zars. I also appreciate the involvement of Nicole Aeby, Ashley Woods, and my other friends at Lookat. Pedro Linger G. was of extraordinary help with the scans and digital layout.

Friends and colleagues who provided encouragement and resources include Abbas, Jaime Abello B. of the Fundación del Nuevo Periodismo, Kristen Ashburn, Jocelyne Benzakin, Claudia Bernardi, Sue Brisk, Flor Cordero, Mercedes Doretti, Anthony Ferranti, Tom Fiehrer, Frank Fournier, Robert Friedman of *Life*, Karen Furth, Piero Guerrini, Tomás Guillermo, Dimitri Hadzi, Ron Haviv, Anne Hohenstein, Eric Ingersoll, Steve Lehman, David Lindner, Rob Maass, Pascal Maitre, Gary Metz, June Nash, Liliana Nieto del Rio, Geoff O'Connor, Hillary Raskin, Albor Rodríguez, Sally Stapleton, Marcel Saba, Alex Webb, and David Wood. I am also grateful to the staff of the Hispanic Society, for patiently searching their collection for rare documents.

I want to thank Andrea Monfried and Steve Sears of The Monacelli Press for editing and producing the book with such attention, taste, and intelligence. Thanks also to Sasha Cutter and Laura Gentile for all their support, and to Tom Whitridge of Ink, Inc., for his superb use of type. And of course, I especially want to thank my publisher, Gianfranco Monacelli.

*Dedicated with love to the memory of my aunt
Bernice Davidson*

*and to the men, women, and children of the
Unificada Mining Cooperative, Potosí, Bolivia*

First published in the United States of America in 1999 by
The Monacelli Press, Inc.
10 East 92nd Street, New York, New York 10128.

Library of Congress Cataloging-in-Publication Data
Ferry, Stephen.
I am rich Potosí : the mountain that eats men / Stephen Ferry.
p. cm.
ISBN 1-58093-028-X
1. Potosí (Bolivia)—Pictorial works. 2. Potosí (Bolivia)—Social
life and customs—Pictorial works. 3. Silver mines and mining—
Bolivia—Potosí—Pictorial works. I. Title.
F3351.P85F48 1999
984'.14-DC21 99-10703

Printed and bound in Italy

Designed by Ink, Inc.

CONTENTS

A Monument
to the Conquest

I FIRST WENT TO POTOSI IN 1991, AS THE SOUTH AMERICAN
correspondent of a photojournalism agency, in anticipation of the five-
hundredth anniversary of Columbus's voyage to America. Rather than glo-
rify the Age of Discovery, I felt it was important to show the other side of
the coin. My goal was to focus on a particular place and document the long-
term effects of the conquest on the native people there. But why choose
Potosí, a forgotten mining town in the barren highlands of Bolivia, as
emblematic of the whole era?

The lust for treasure that motivated the Spanish was sated when they
first cut into the Cerro Rico (Rich Mountain) of Potosí in 1545. For over two
hundred years, the mountain yielded more than half of the world's produc-
tion of silver. This flow of wealth financed Spain's empire, influenced the
course of European economic development, and bolstered Europe's trade
relations with China. During the colonial period, the Cerro Rico became
world-famous, the subject of chronicles, poems, and paintings that cele-
brated its grandeur and generosity.

At the same time, the mining project in Potosí provoked one of the
worst demographic disasters in history. In 1575, the viceroy of Peru,
Francisco de Toledo, created the *mita*, a forced-labor system that remained
in place for 250 years. Under the *mita*, some three million Quechua Indians
were made to work in the mines. Hundreds of thousands died there, of dis-
ease, from accidents, and at the brutal hands of their masters. Peasants fled
as best they could, abandoning the land, but many were forced into *reduc-*

ciones, concentration areas where they could be counted and conscripted. Although historians disagree over the size of the pre-conquest population, they concur that over the course of the *mita* (1575–1825), the native population of the Andes declined by 80 percent.

I went to Potosí to find traces of this great crime in the daily life of the ten thousand or so mining families still working there. These miners, who are direct descendants of the Quechua enslaved during the colonial period, successfully resisted the destruction of their culture, and over the centuries they have developed powerful symbolic ways of interacting with the Cerro Rico and with their own past. But in economic terms, the Quechua never recovered from the *mita:* the Department of Potosí is the poorest place in all the Americas, a place where 230 babies out of 1,000 die by the age of five. I looked at both the rich culture of the miners and their economic plight as windows onto history.

Life in Potosí has the feel of a cruel myth. Men there are compelled to repeat the past, working themselves to death in the very mountain that was the tomb of their ancestors. Inside the Cerro Rico, the miners worship a devil, a rapacious deity with the clothes of a miner and the beard of a Spaniard. Several times a year, they sacrifice llamas to this being, adorning the mouth of the mine with blood, so that he will not eat them. At carnival time, the miners dance out their history, dressed as Spanish lords, African slaves, and the devil. Ever present, the Cerro Rico looms iconically over the city, as if it were a giant monument to the conquest of the Americas.

—S. F.

The Splendors of Potosí

Eduardo Galeano

THEY SAY THAT EVEN THE HORSES WERE SHOD WITH SILVER IN THE great days of the city of Potosí. The church altars and the wings of cherubim in processions for the Corpus Christi celebration in 1658 were made of silver: the streets from the cathedral to the church of Recoletos were completely resurfaced with silver bars. In Potosí, silver built temples and palaces, monasteries and gambling dens; it prompted tragedies and fiestas, led to the spilling of blood and wine, fired avarice, and unleashed extravagance and adventure. The sword and the cross marched together in the conquest and plunder of Latin America, and captains and ascetics, knights and evangelists, soldiers and monks came together in Potosí to help themselves to its silver. Molded into cones and ingots, the viscera of the Cerro Rico—the rich hill—substantially fed the development of Europe. "Worth a Peru" was the highest possible praise of a person or a thing after Pizarro took Cuzco, but once the Cerro had been discovered Don Quixote de la Mancha changed the words: "Worth a Potosí," he says to Sancho. This jugular vein of the viceroyalty, America's fountain of silver, had 120,000 inhabitants by the census of 1573. Only twenty-eight years had passed since the city sprouted out of the Andean wilderness and already, as if by magic, it had the same population as London and more than Seville, Madrid, Rome, or Paris. A new census in 1650 gave Potosí a population of 160,000. It was one of the

world's biggest and richest cities, ten times bigger than Boston—at a time when New York had not even begun to call itself by that name.

Potosí's history did not begin with the Spaniards. Before the conquest the Inca Huayna Cápaj had heard his vassals talk of the Sumaj Orcko, the beautiful hill, and he was finally able to see it when, having fallen ill, he had himself taken to the thermal springs of Tarapaya. From the straw-hut village of Cantumarca the Inca's eyes contemplated for the first time that perfect cone which rises proudly between the mountain peaks. He was awestruck by its reddish hues, slender form, and giant size, as people have continued to be through ensuing centuries. But the Inca suspected that it must conceal precious stones and rich metals in its bowels, and he wanted to add new decorations to the Temple of the Sun in Cuzco. The gold and silver that the Incas took from the mines of Colque Porco and Andacaba did not leave the kingdom: they were not used commercially but for the adoration of the gods. Indian miners had hardly dug their flints into the beautiful Cerro's veins of silver when a deep, hollow voice struck them to the ground. Emerging as loud as thunder from the depths of the wilderness, the voice said in Quechua: "This is not for you; God is keeping these riches for those who come from afar." The Indians fled in terror and the Inca, before departing from the Cerro, changed its name. It became "Potojsi," which means to thunder, burst, explode.

"Those who come from afar" took little time in coming, although Huayna Cápaj was dead by the time the captains of the conquest made their way in. In 1545 the Indian Huallpa, running in pursuit of an escaped llama, had to pass the night on the Cerro. It was intensely cold and he lit a fire. By its light he saw a white and shining vein—pure silver. The Spanish avalanche was unleashed.

Wealth flowed like water. The Holy Roman Emperor, Charles V, showed his gratitude by bestowing on Potosí the title of Imperial City and a shield with the inscription: "I am rich Potosí, treasure of the world, king of the mountains, envy of kings." Only eleven years after Huallpa's discovery the new-born Imperial City celebrated the coronation of Philip II with twenty-four days of festivities costing eight million *pesos duros.* The Cerro was the most potent of magnets. Hard as life was at its base, at an altitude of nearly 14,000 feet the place was flooded with treasure hunters who took the bitter cold as if it were a tax on living there. Suddenly a rich and disorderly society burst forth beside the silver, and Potosí became "the nerve center of the

kingdom," in the words of Viceroy Antonio de Mendoza. By the beginning of the seventeenth century it had thirty-six magnificently decorated churches, thirty-six gambling houses, and fourteen dance academies. Salons, theaters, and fiesta stage-settings had the finest tapestries, curtains, heraldic emblazonry, and wrought gold and silver; multicolored damasks and cloths of gold and sliver hung from the balconies of houses. Silks and fabrics came from Granada, Flanders, and Calabria; hats from Paris and London; diamonds from Ceylon; precious stones from India; pearls from Panama; stockings from Naples; crystal from Venice; carpets from Persia; perfumes from Arabia; porcelain from China. The ladies sparkled with diamonds, rubies, and pearls; the gentlemen sported the finest embroidered fabrics from Holland. Bullfights were followed by tilting contests, and love and pride inspired frequent medieval-style duels with emerald-studded, gaudily plumed helmets, gold filigree saddles and stirrups, Toledo swords, and richly caparisoned Chilean ponies.

In 1579 the royal judge Matienzo complained: "There is never a shortage of novelty, scandal, and wantonness." Potosí had at the time 800 professional gamblers and 120 famous prostitutes, whose resplendent salons were thronged with wealthy miners. In 1608 Potosí celebrated the feast of the Holy Sacrament with six days of plays and six nights of masked balls, eight days of bullfights and three of fiestas, two of tournaments and other dissipations...

The colonial Latin American economy enjoyed the most highly concentrated labor force known until that time, making possible the greatest concentration of wealth ever enjoyed by any civilization in world history... The price of the tide of avarice, terror, and ferocity bearing down on these regions was Indian genocide... In three centuries Potosí's Cerro Rico consumed eight million lives. The Indians, including women and children, were torn from their agricultural communities and driven to the Cerro. Of every ten who went up into the freezing wilderness, seven never returned. Luis Capoche, an owner of mines and mills, wrote that "the roads were so covered with people that the whole kingdom seemed on the move." In their communities the Indians saw "many afflicted women returning without husbands and with many orphaned children" and they knew that "a thousand deaths and disasters" awaited them in the mines. The Spaniards scoured the countryside for hundreds of miles for labor. Many died on the way, before reaching Potosí, but it was the terrible work conditions in the mine that killed the most people. Soon after the mine began operating, in

1550, the Dominican monk Domingo de Santo Tomás told the Council of the Indies that Potosí was a "mouth of hell" which swallowed Indians by the thousands every year, and that rapacious mine owners treated them "like stray animals." Later Fray Rodrigo de Loaysa said: "These poor Indians are like sardines in the sea. Just as other fish pursue the sardines to seize and devour them, so everyone in these lands pursues the wretched Indians." Chiefs of Indian communities had to replace the constantly dying *mitayos* with new men between eighteen and fifty years old. The huge stone-walled corral where Indians were assigned to mine and mill owners is now used by workers as a football ground. The *mitayos'* jail—a shapeless mass of ruins—can still be seen at the entrance to Potosí...

In the sixteenth and seventeenth centuries the Cerro Rico of Potosí... was the hub of Latin American colonial life: around it, in one way or another, revolved the Chilean economy, which sent it wheat, dried meat, hides, and wines; the cattle-raising and crafts of Córdoba and Tucumán in Argentina, which supplied it with draft animals and textiles; the mercury mines of Huancavelica; and the Arica region whence the silver was shipped to Lima, chief administrative center of the period. In the independence period the area, now a part of Bolivia, still had a larger population than what is now Argentina. A century and a half later Bolivia's population is almost six times smaller than Argentina's.

Potosían society, sick with ostentation and extravagance, left Bolivia with only a vague memory of its splendors, of the ruins of its churches and palaces, and of eight million Indian corpses. Any one of the diamonds encrusted in a rich *caballero*'s shield was worth more than what an Indian could earn in his whole life under the *mitayo*, but the *caballero* took off with the diamonds. If it were not a futile exercise, Bolivia—now one of the world's most poverty-stricken countries—could boast of having nourished the wealth of the wealthiest. In our time Potosí is a poor city in a poor Bolivia: "The city which has given most to the world and has the least," as an old Potosían lady, enveloped in a mile of alpaca shawl, told me when we talked on the Andalusian patio of her two-century-old house. Condemned to nostalgia, tortured by poverty and cold, Potosí remains an open wound of the colonial system in America: a still audible "J'accuse."

From *Open Veins of Latin America: Five Centuries of the Pillage of a Continent*, 1971

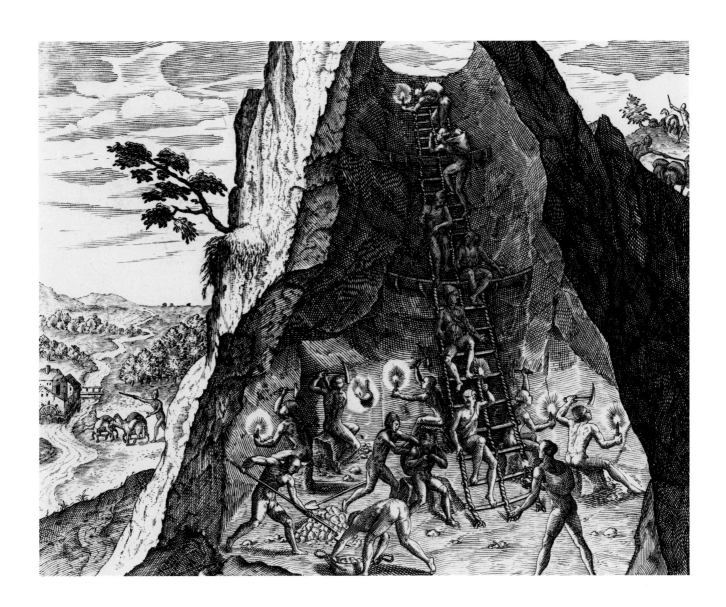

The Rich Mountain

There have been men who, having entered only out of curiosity to see that horrible labyrinth, have come out totally robbed of color, and (grinding tooth against tooth) have not been able to pronounce a word (effects of the horror that they have just experienced); they have not known even how to ponder it nor make reference to the terrors that are in there, because there are places where no matter how high you lift your head you cannot see the top, and looking below you cannot see the bottom; on one side you see a horror, on another a fright, and everything that you see in there is all confusion.

—BARTOLOME ARZANS DE ORSUA Y VELA,
HISTORY OF THE IMPERIAL CITY OF POTOSI, 1703

If you see the Tío, the devil, walking around, you can go crazy or die of fear. The Tío is God here: if he wants accidents, he will have them.

—BERNABE MAMANI,
CANDELARIA BAJA MINESHAFT, 1997

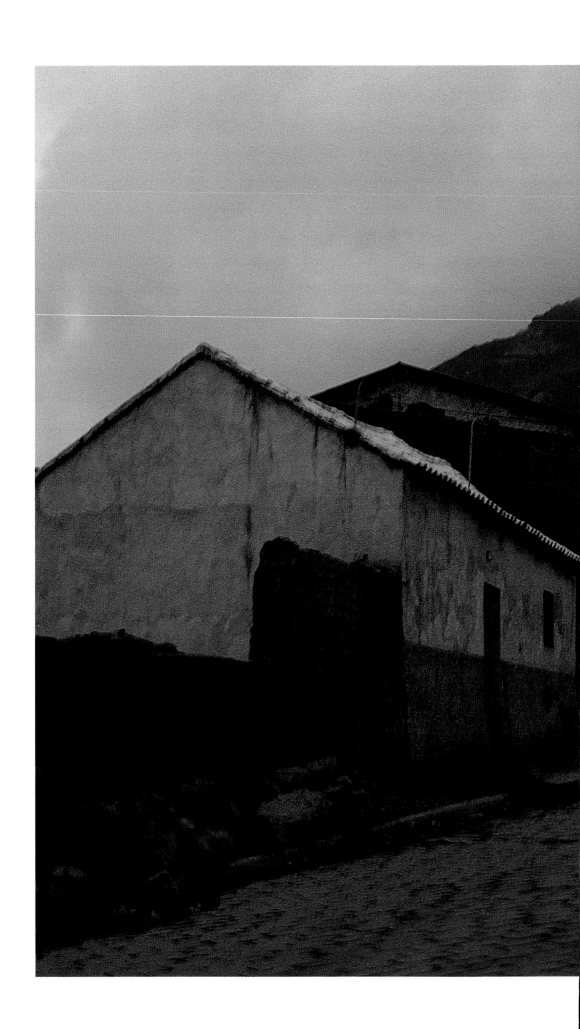

Morning, Calvario.

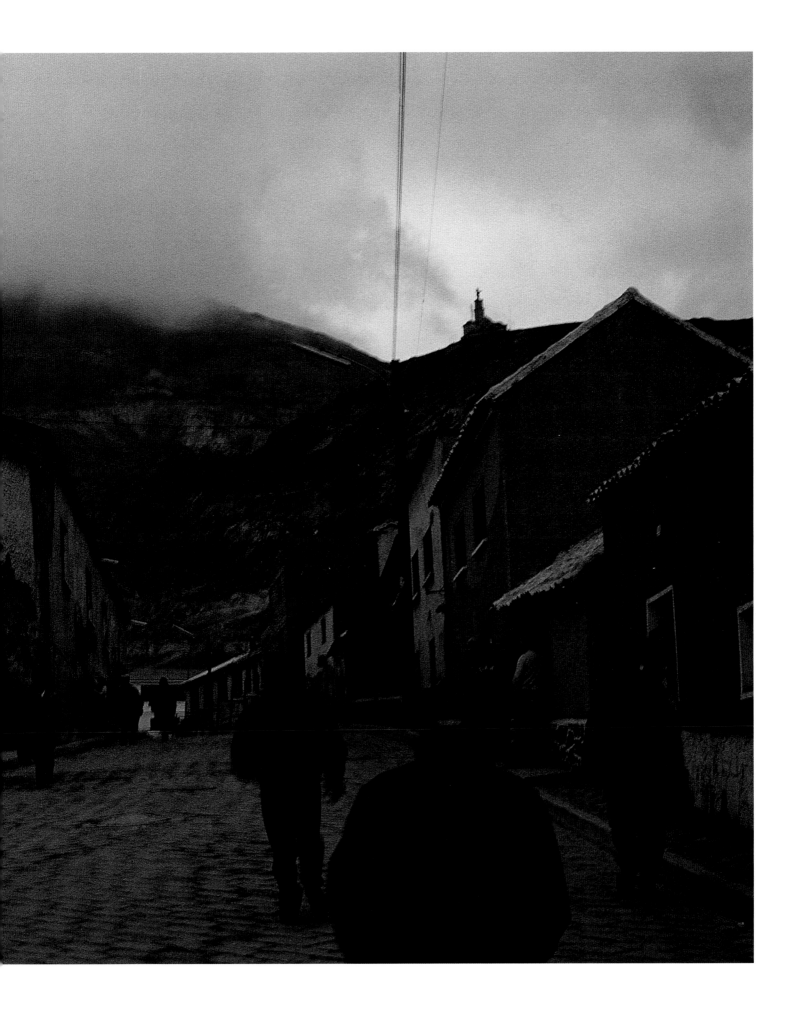

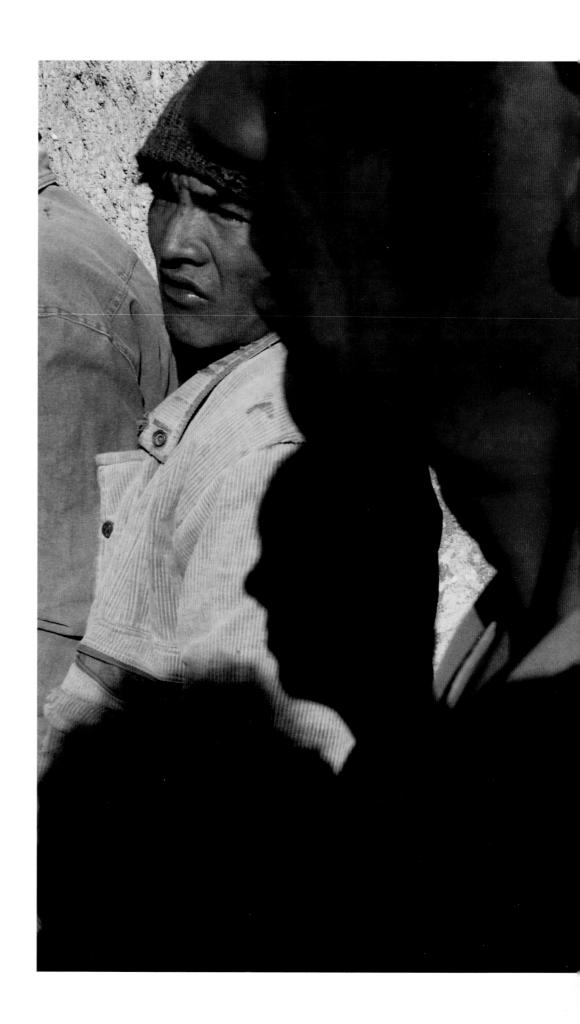

Meeting, Caracoles mine.

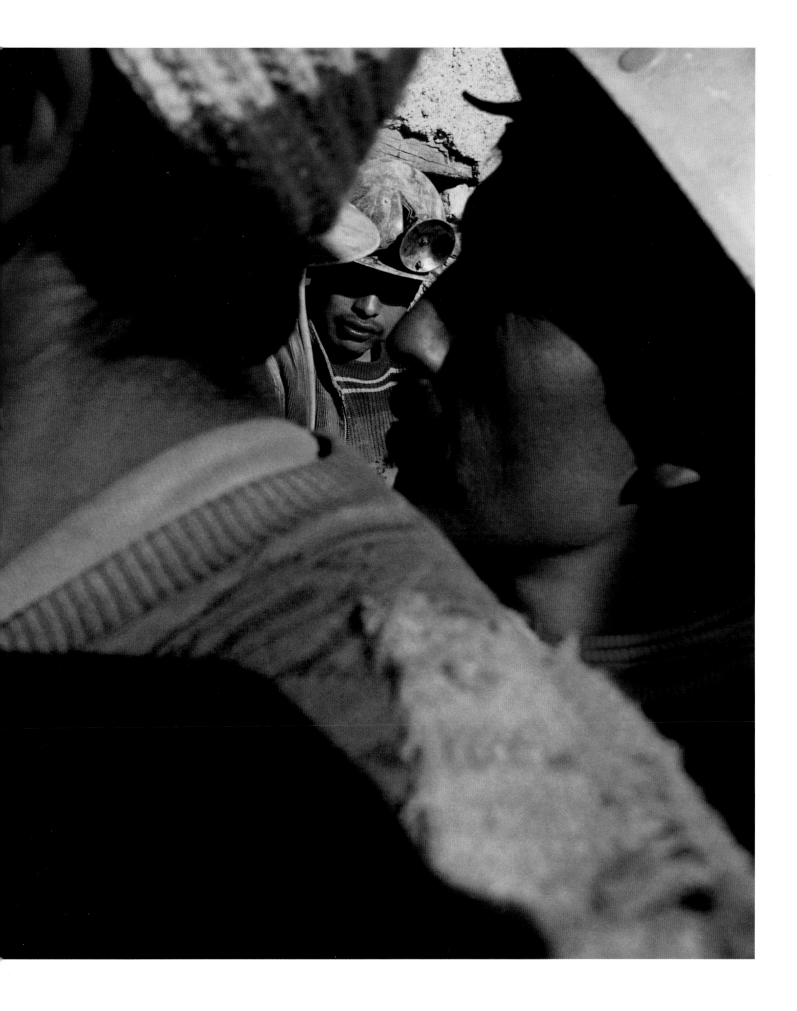

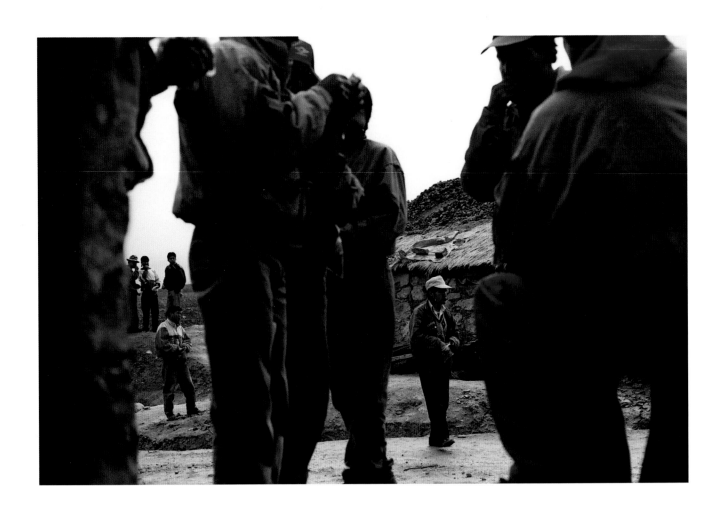

Coca leaf, Santa Rita mine.

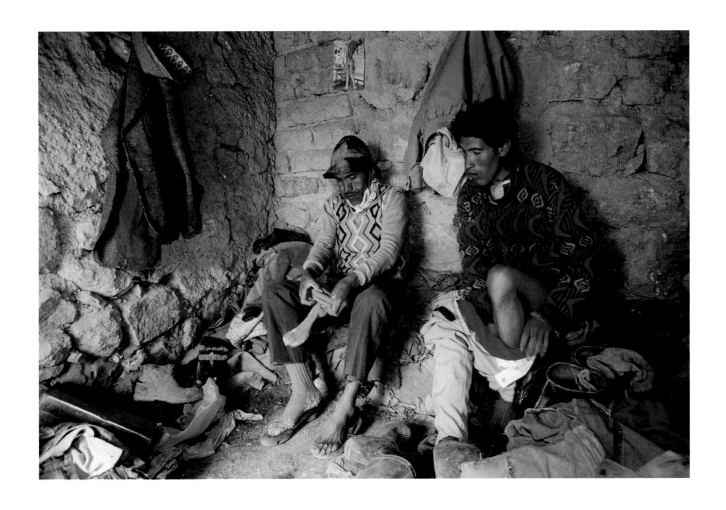

Work clothes, Rosario Bajo mine.

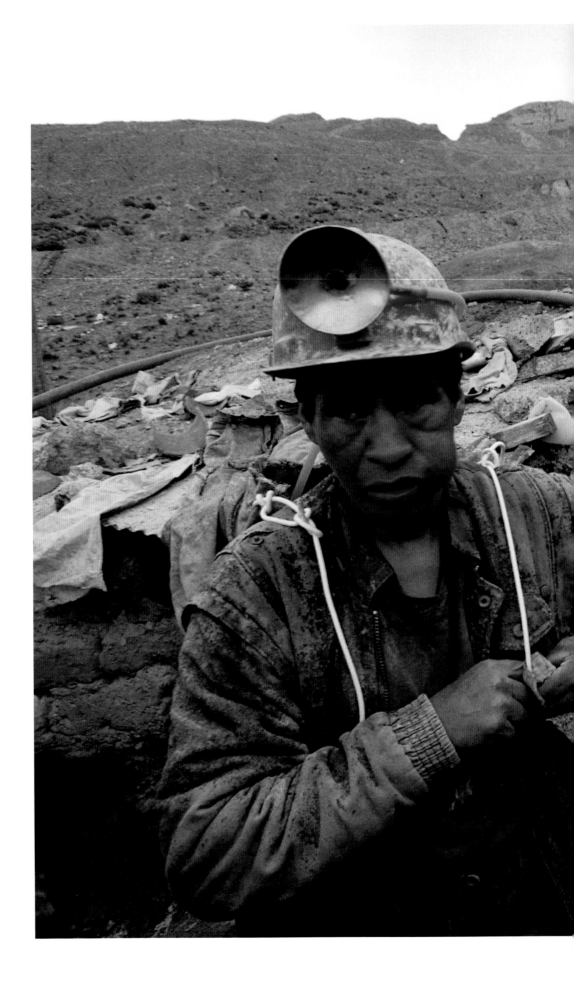

Candelaria Baja mine.

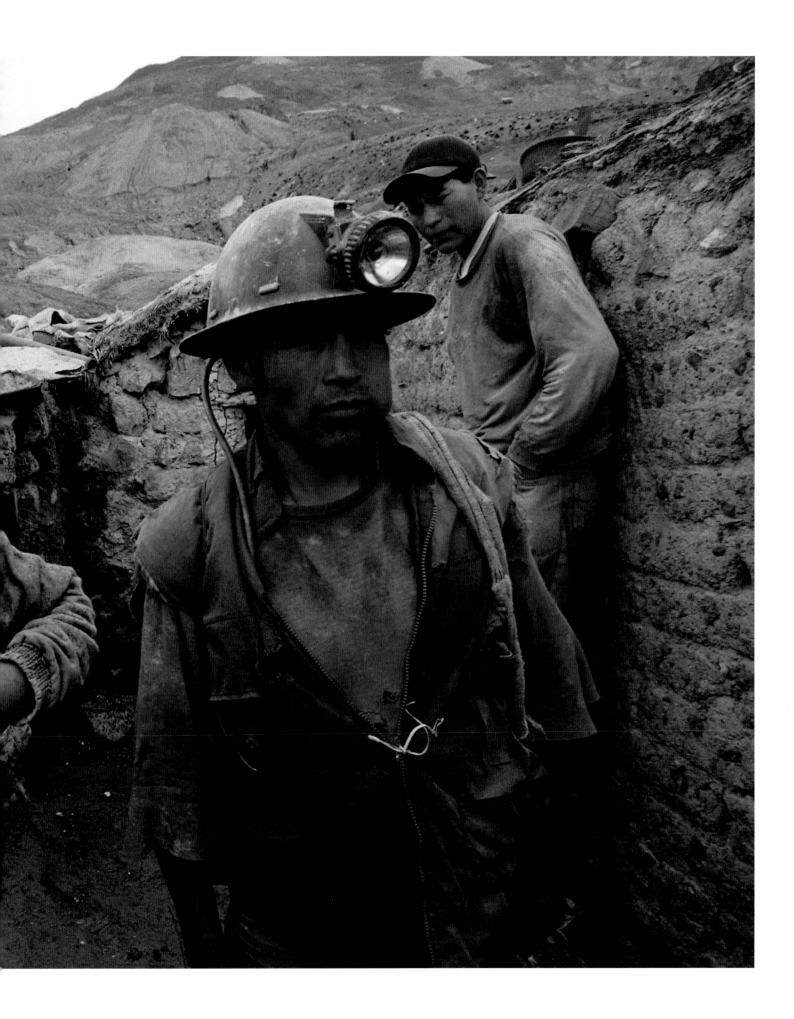

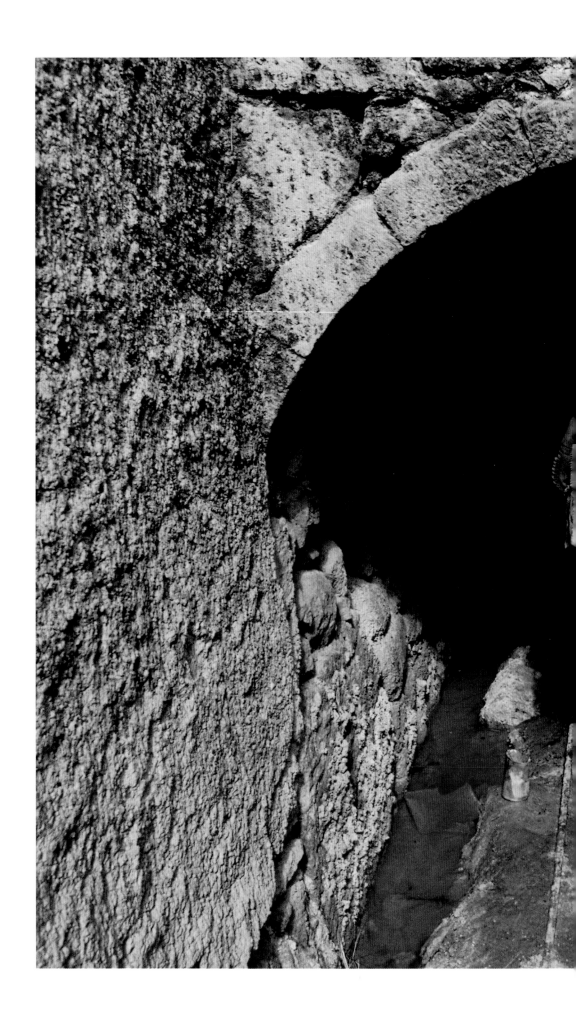

Bocamina, Rosario Bajo.

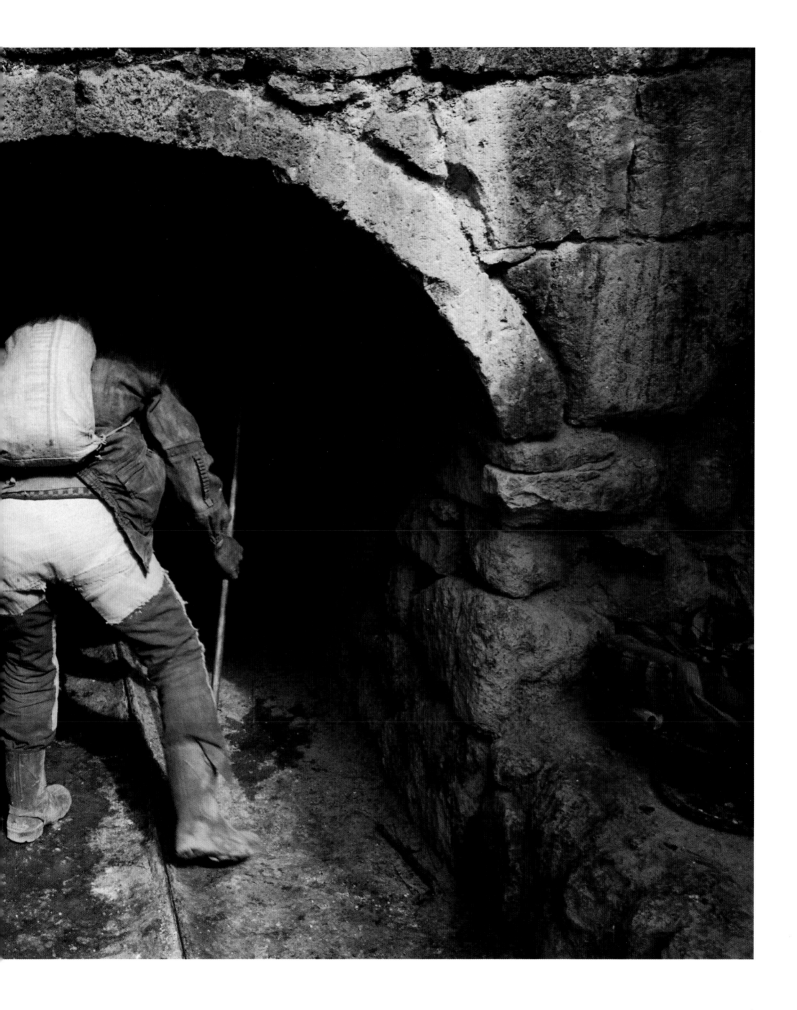

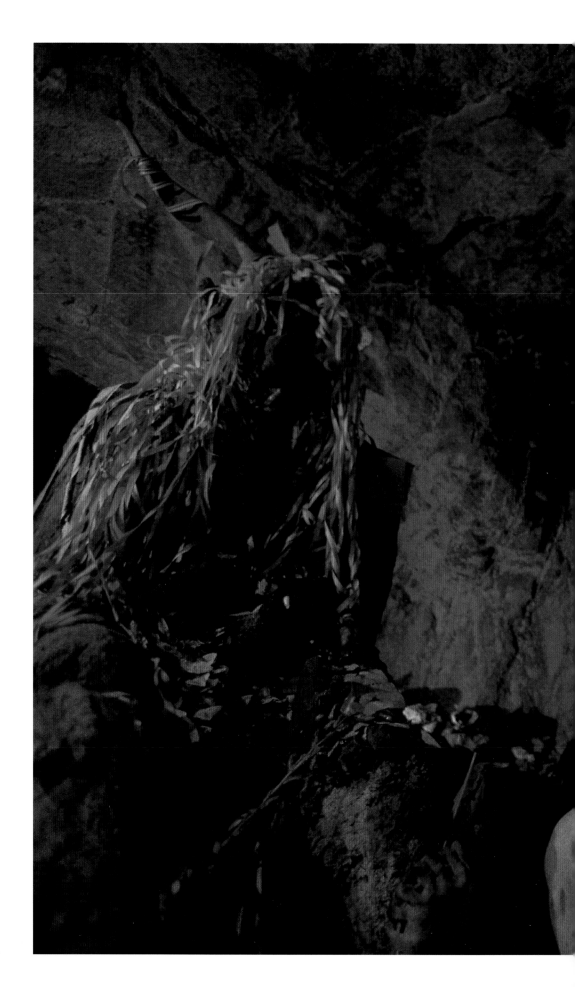

The Tío, first level, Rosario Bajo.

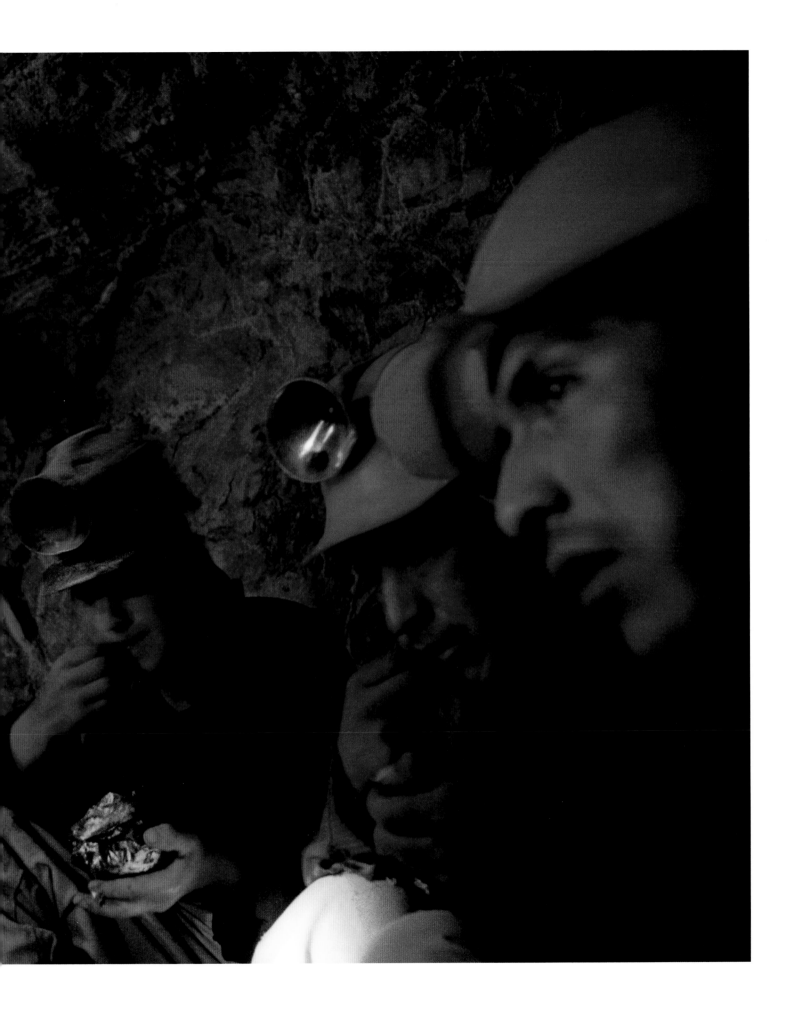

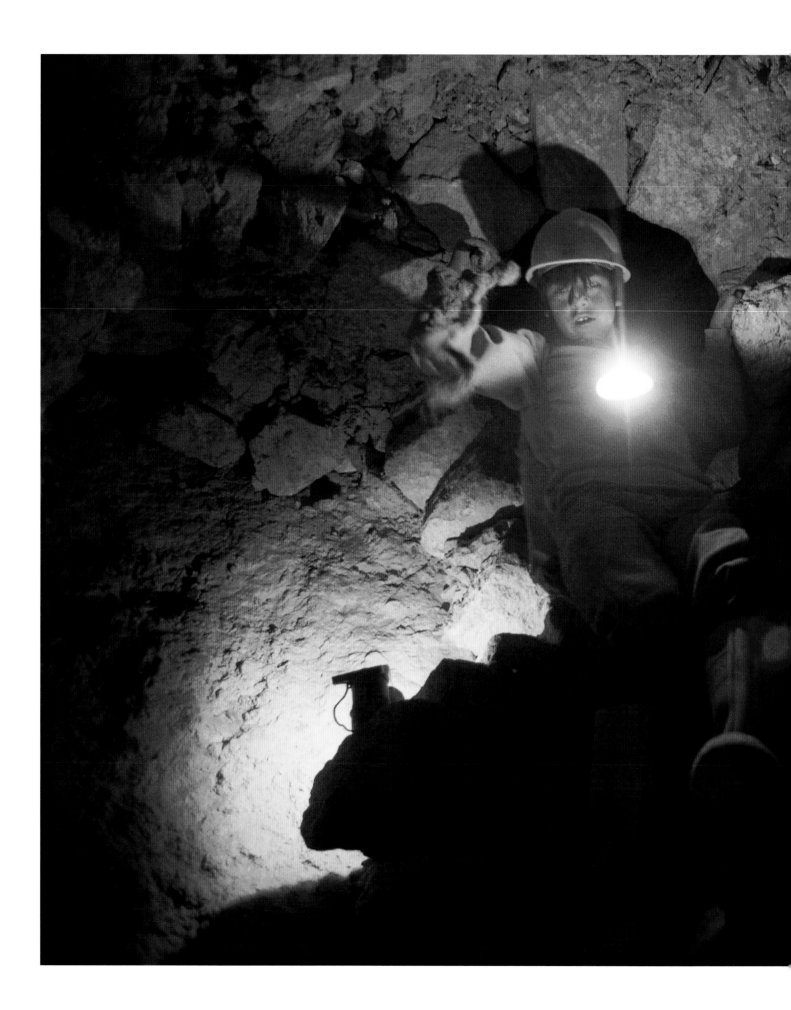

Thirteen-year-old, Santa Rita.

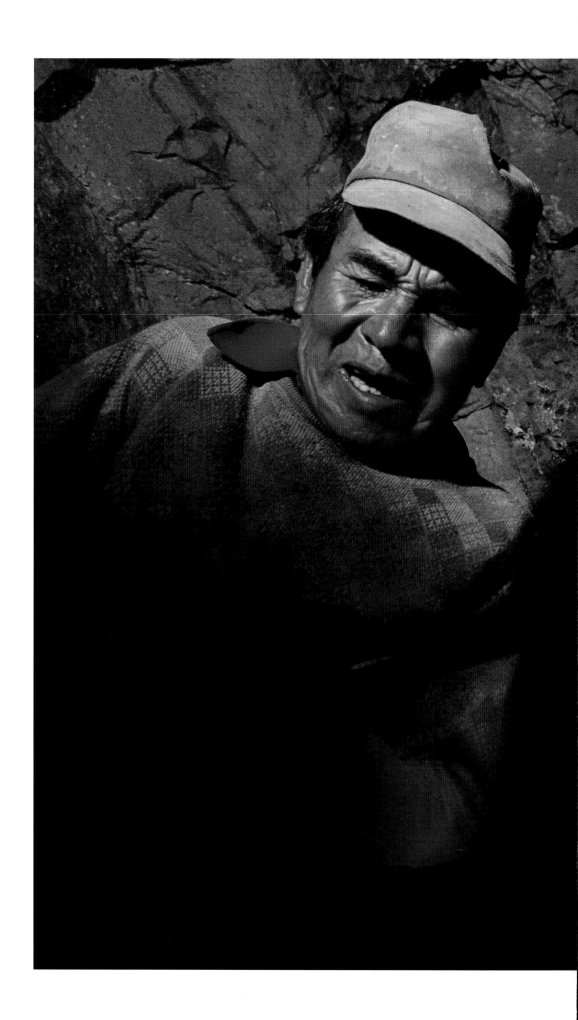

Peon.

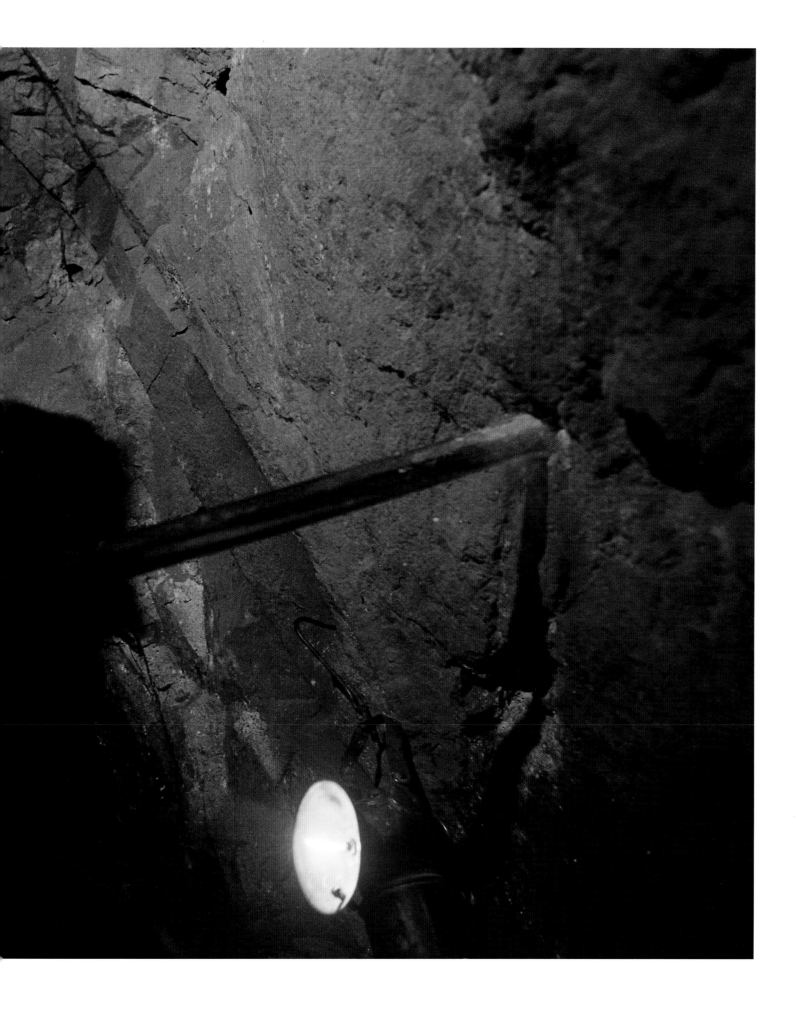

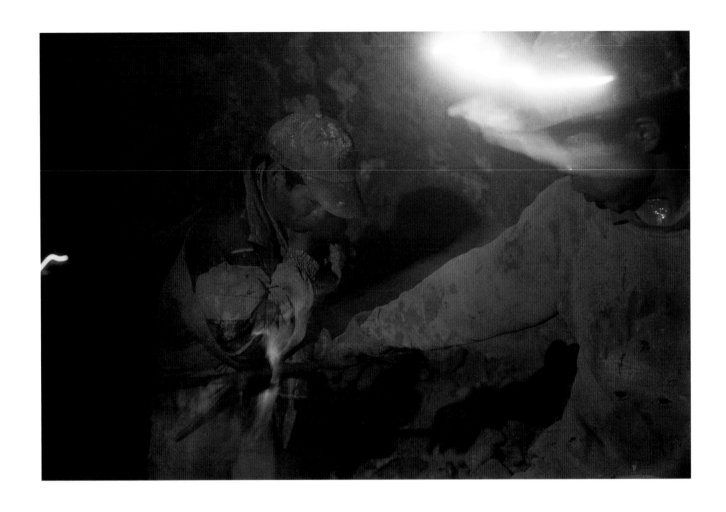

Rosario Bajo.

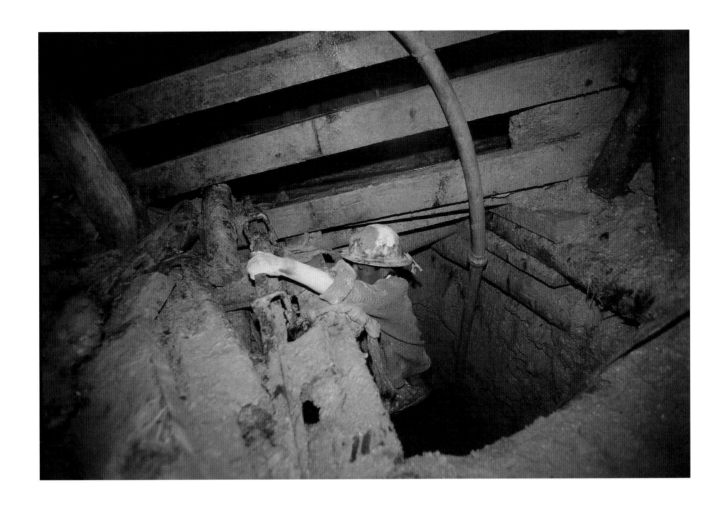

The Lung, Rosario Bajo.

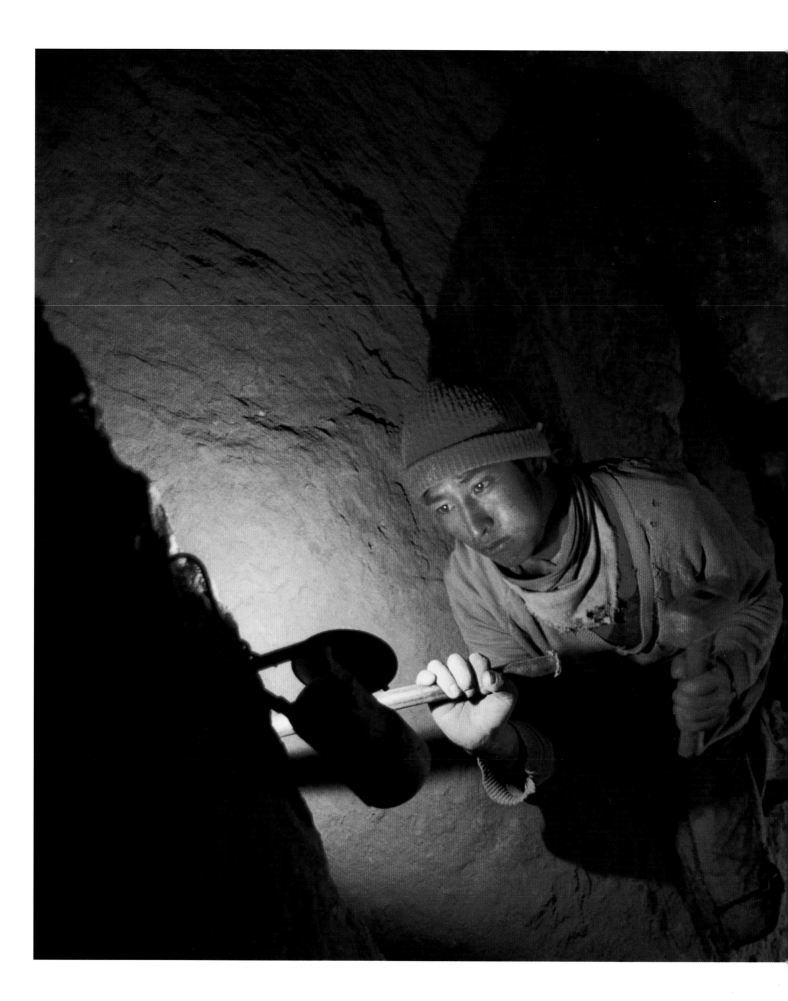

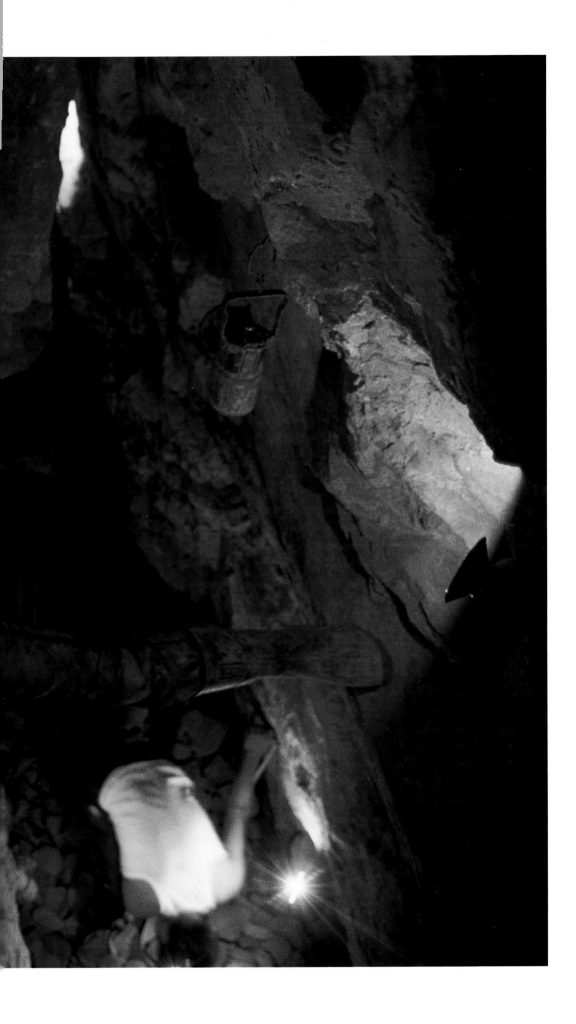

Rosario Bajo.

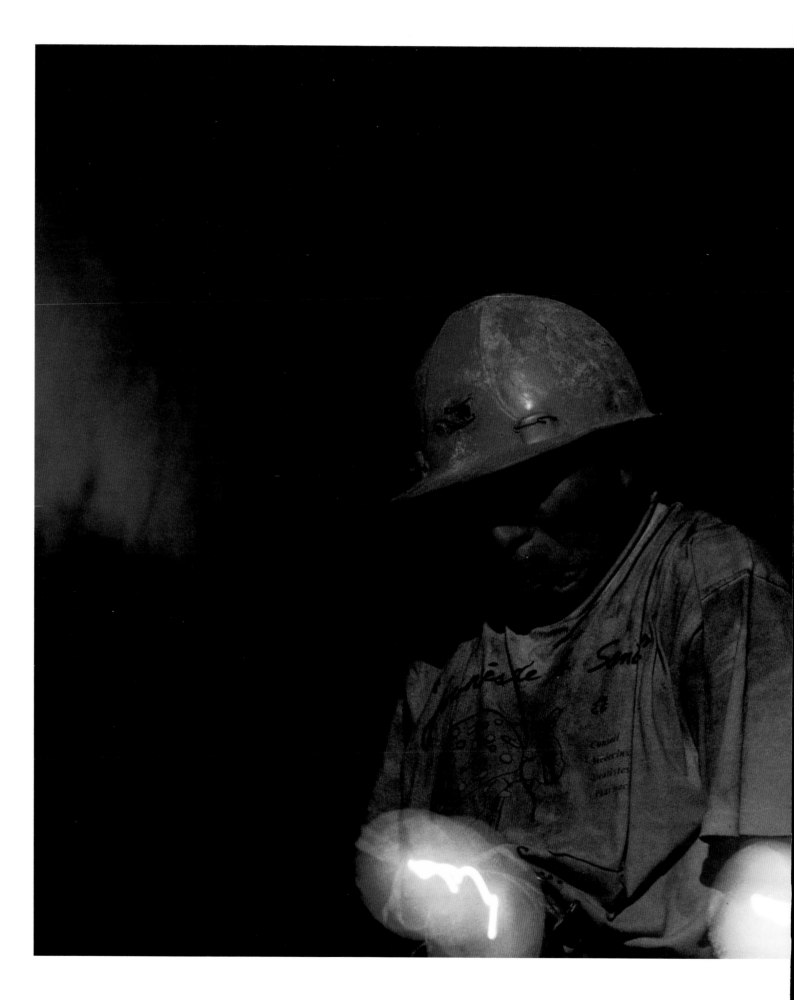

Rosario Bajo.

The Tío, third level, Rosario Bajo.

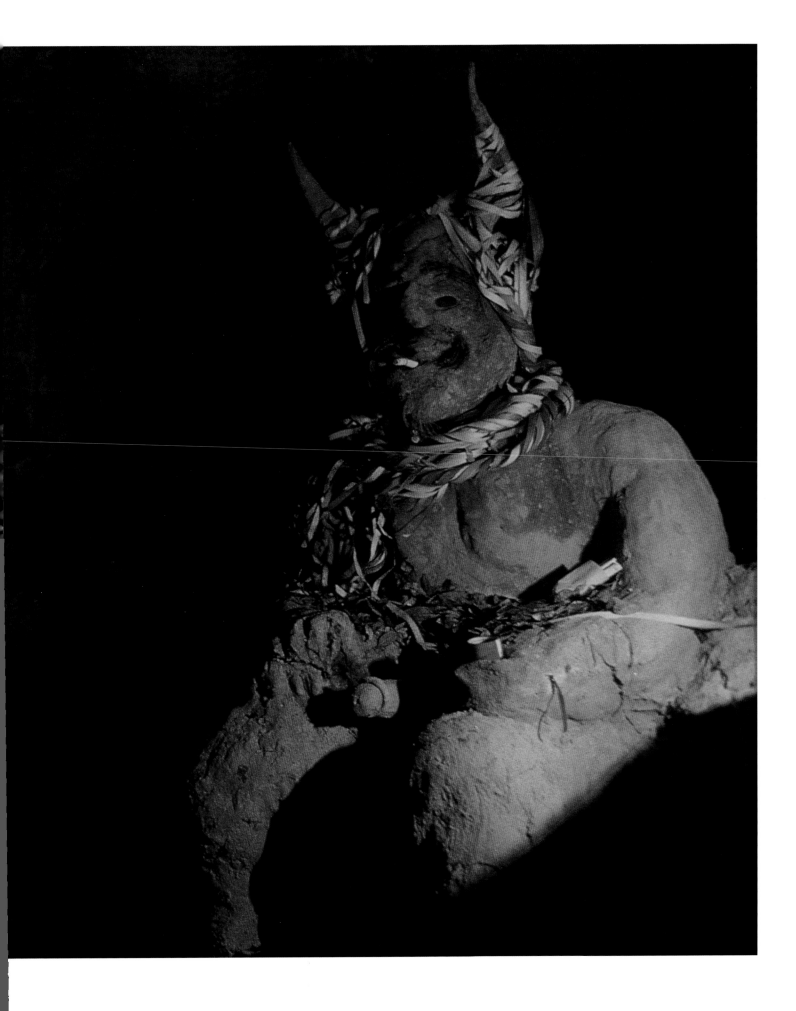

Palliris

The Indian women look for the rocks that are discarded around the mouths of the mine, which is called *pallar,* that is, to break them up and choose those of value and separate them from the rest. And these are all sold at midday in Potosí. And before that hour, no Spaniard can buy anything from an Indian, and this is so that the Indians have a chance to buy these metals, as there are many Indians who buy them for their furnaces. And for this reason, kindling is very expensive, because of these furnaces. Even cattle feces is worth money in Potosí, and Indians walk around in the fields picking up the droppings of the cattle and for each little piece of it the owners of the refineries pay them a peso. And because of the rising cost of everything having to do with this, I say that even the excrement of people is worth money and is sold, and for this reason they have in Potosí some corrals where the Indians who walk the streets go to defecate; and these excrements are dried out in the sun and pressed together into large bulks and for a certain amount of this material they are paid eight *reales,* in order to burn the gray metal and refine it and enhance it with the opaque metal.

—FRIAR DIEGO DE OCANA,
THE FAMOUS CERRO OF POTOSI
AND CUSTOMS OF HER PEOPLE, 1599

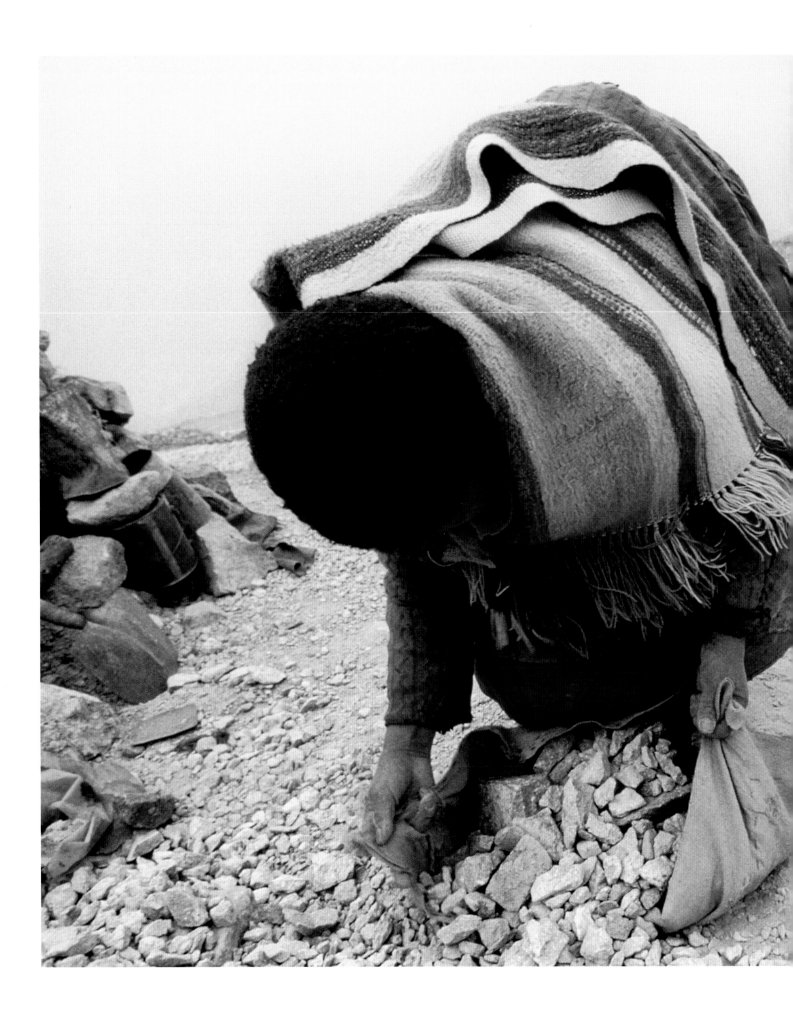

Palliri, San Germán mine.

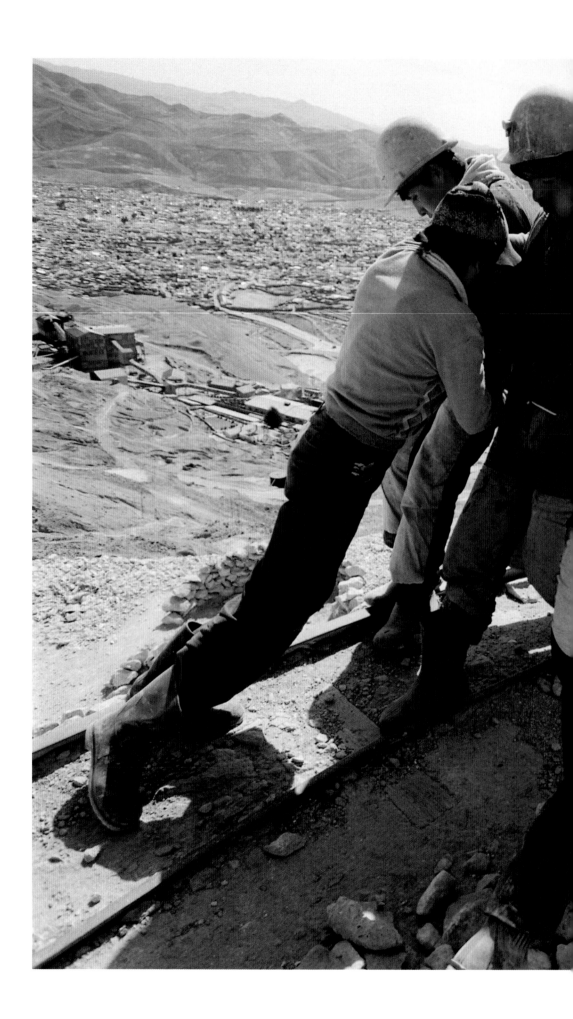

Tailings, Caracoles mine.

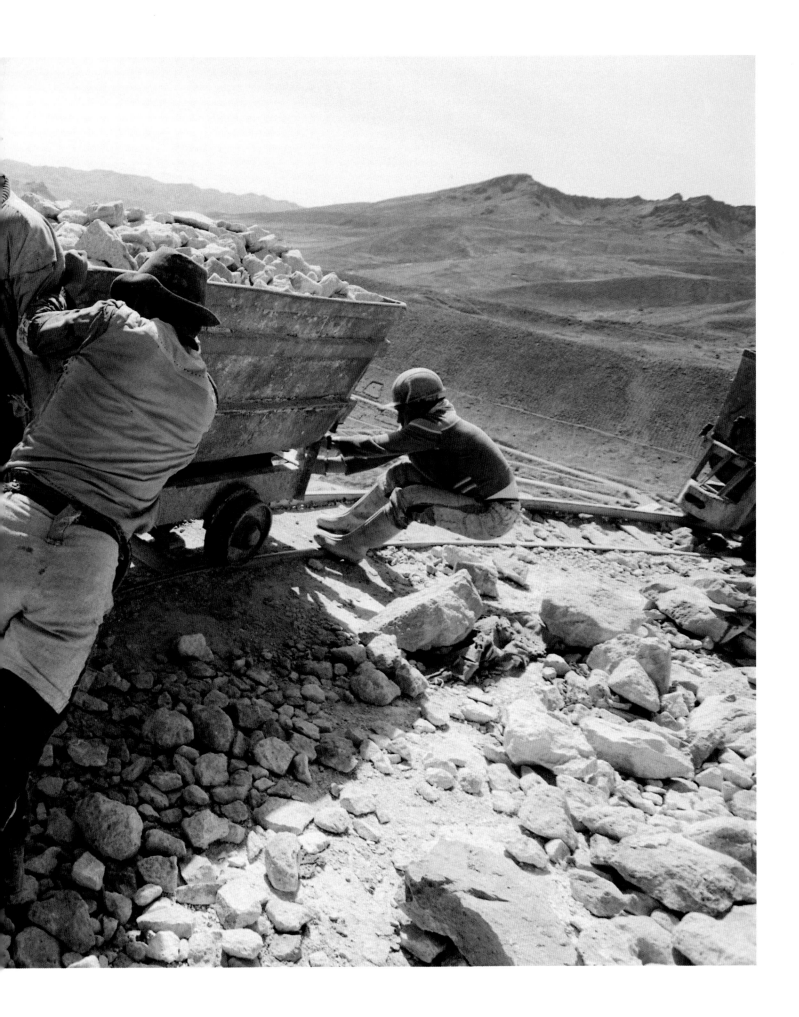

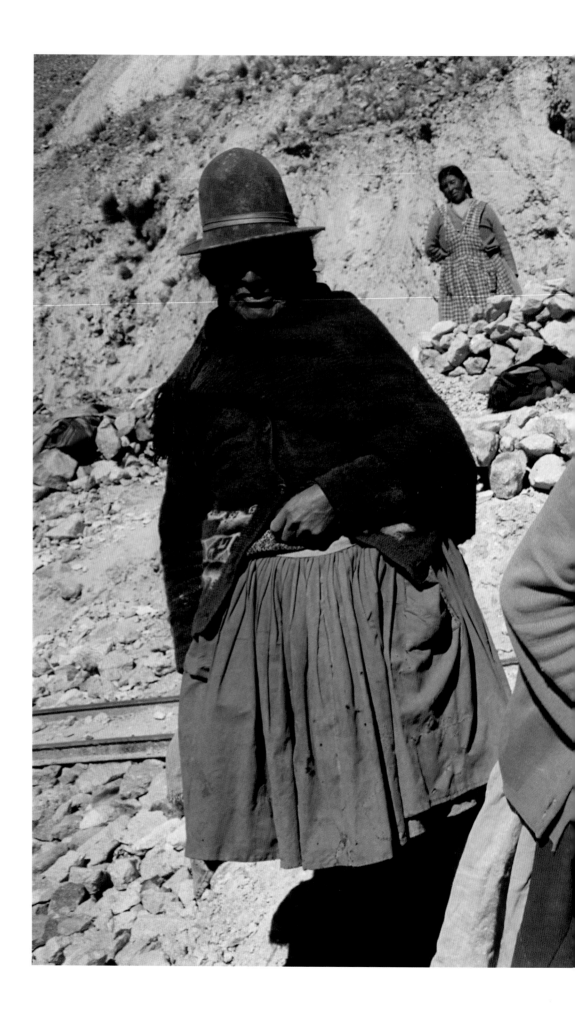

Palliris.

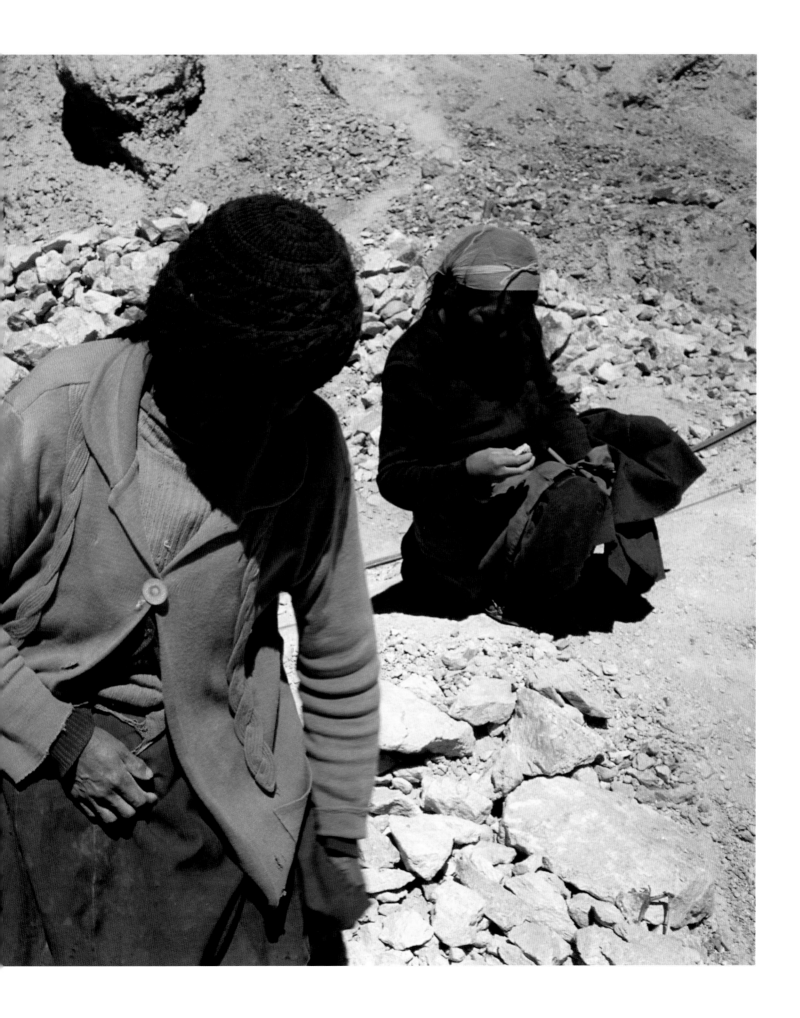

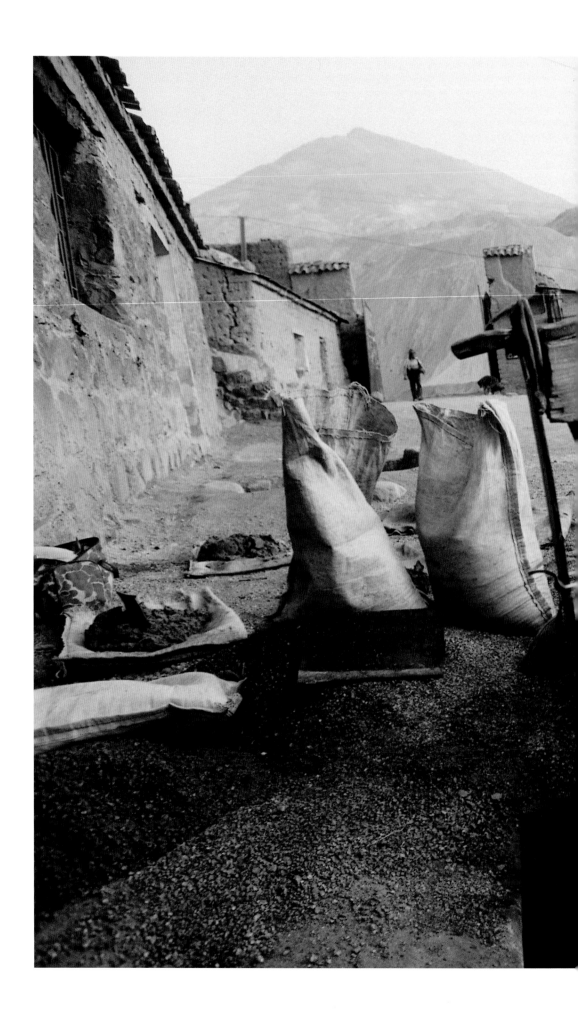

Unificada refinery.

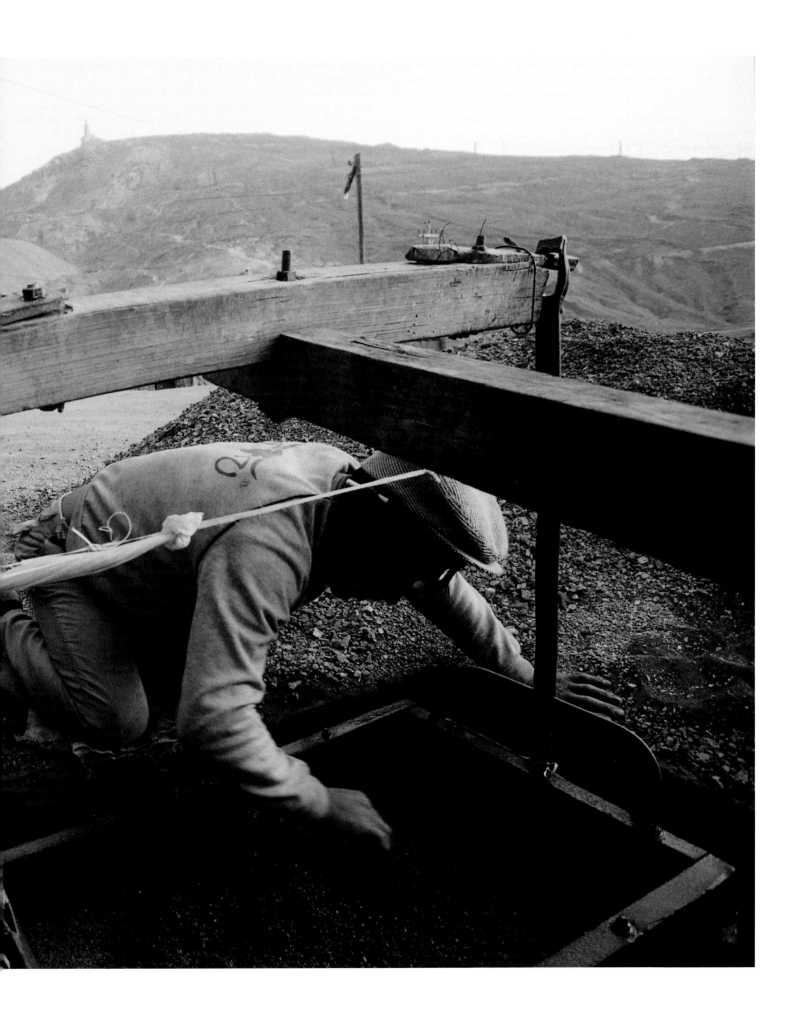

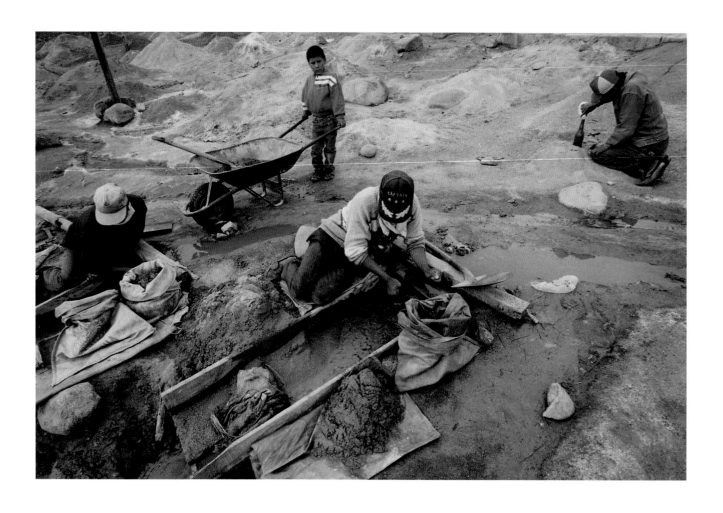

Unificada refinery.

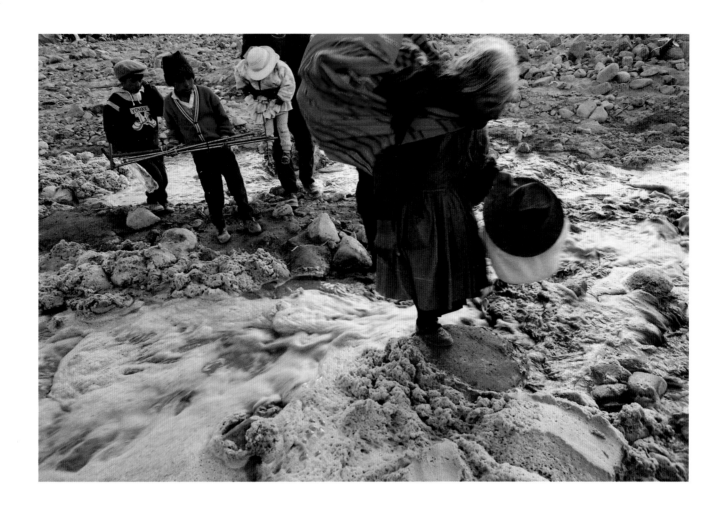

Tarapaya River.

Tarapaya River.

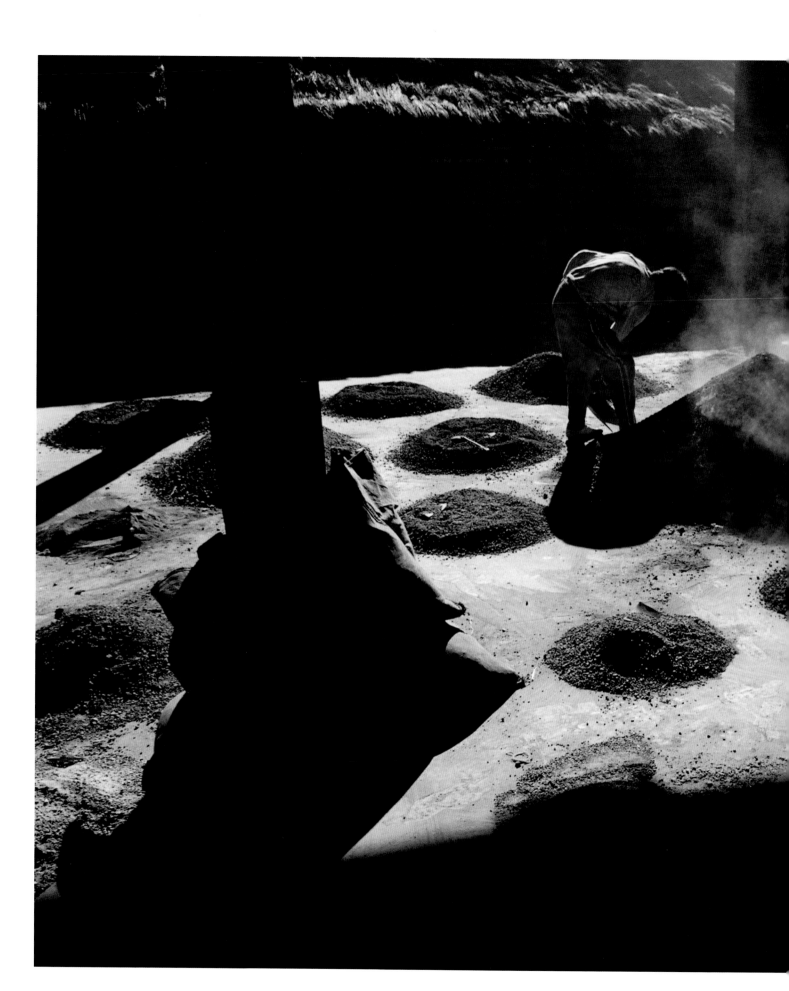

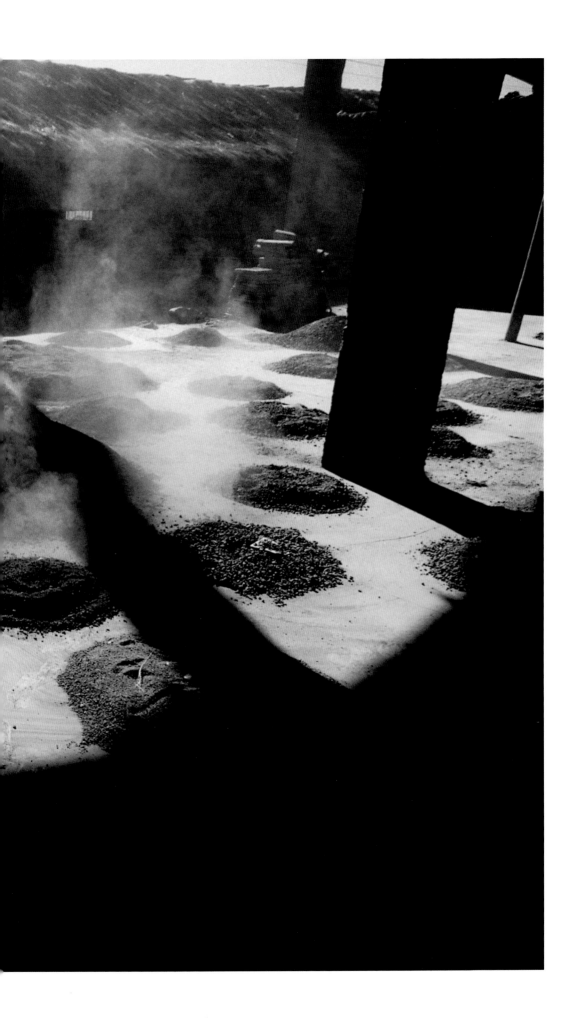

Unificada refinery.

Miners Carnival

The procession made a turn
All around the temple,
Where there were rich altars
All beautifully cared for.
The dances were notable,
The music came from heaven
And of the size of the multitude
It is impossible to say too much.
And once Our Lord was safely inside
Potosí remained transfixed.
The religious were spellbound
As together they had come
To happily celebrate
The Sacrament of Christ.

—EL MARQUES DE XEREZ DE LOS CABALLEROS,
*ACCOUNT OF THE GRAND FESTIVAL THAT THE GOVERNOR LUIS DE
ANDRADE Y SOTOMAYOR ORGANIZED FOR THE RENOVATION OF THE
HOLY SACRAMENT CHURCH,* 1663

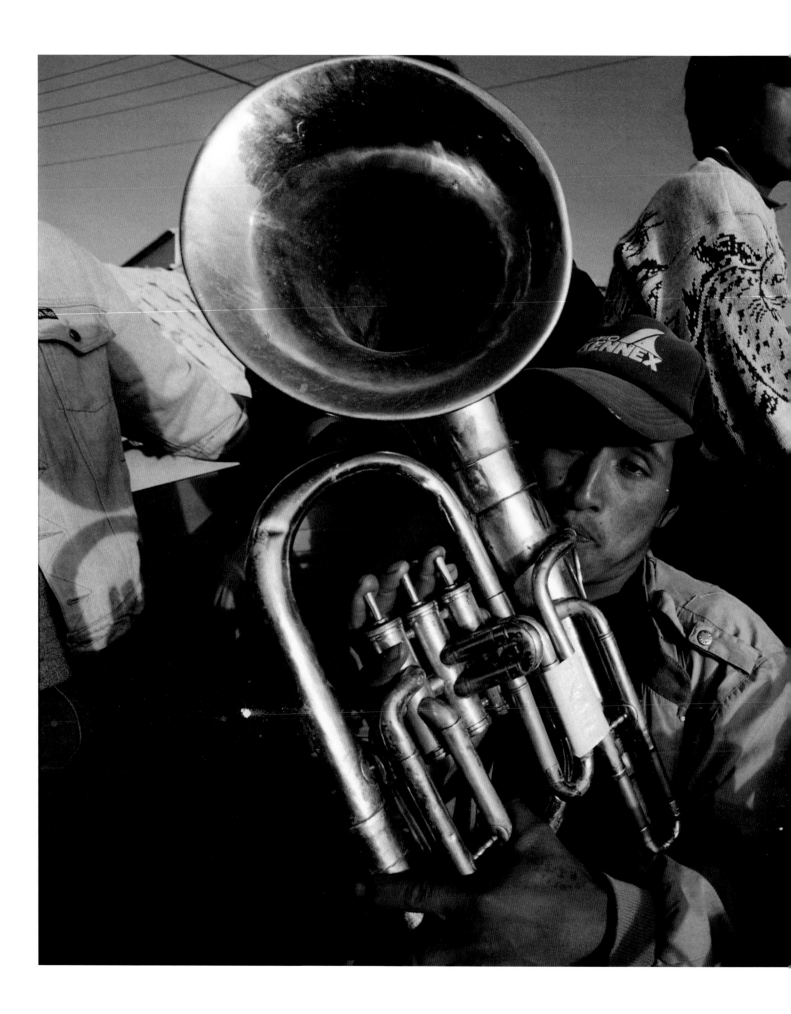

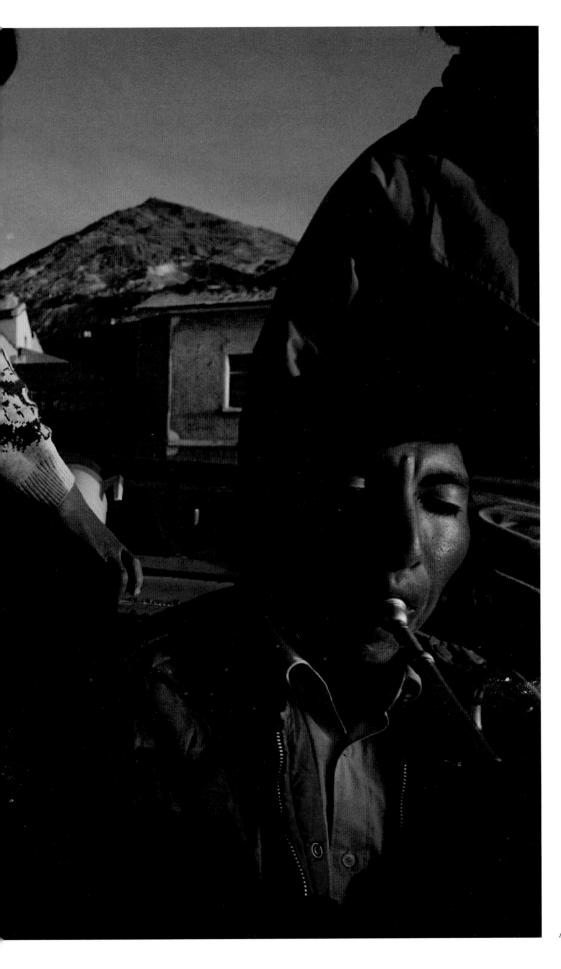

Anniversary of the Santa Rita mine.

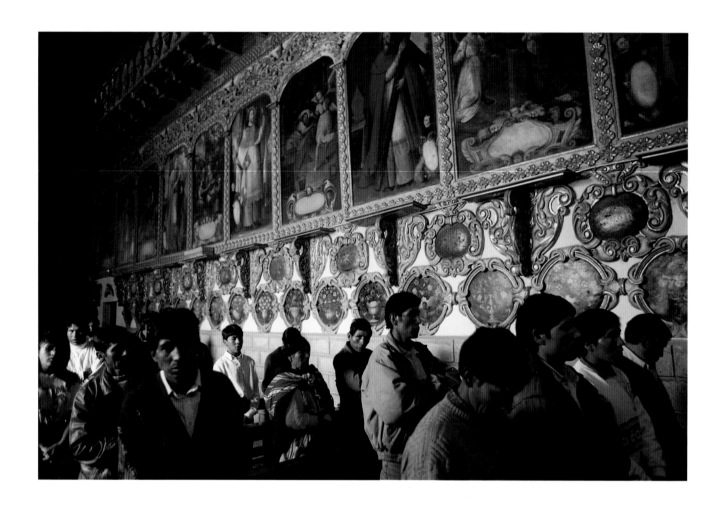

Carnival mass, Church of San Martín.

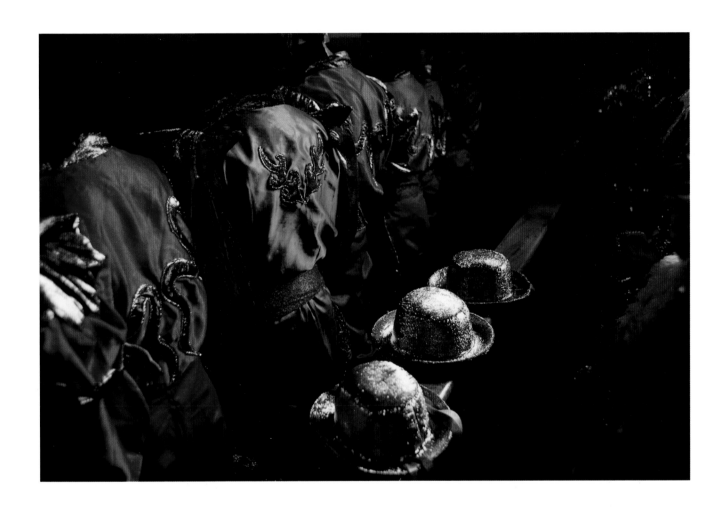

Caporales dancers, Church of San Martín.

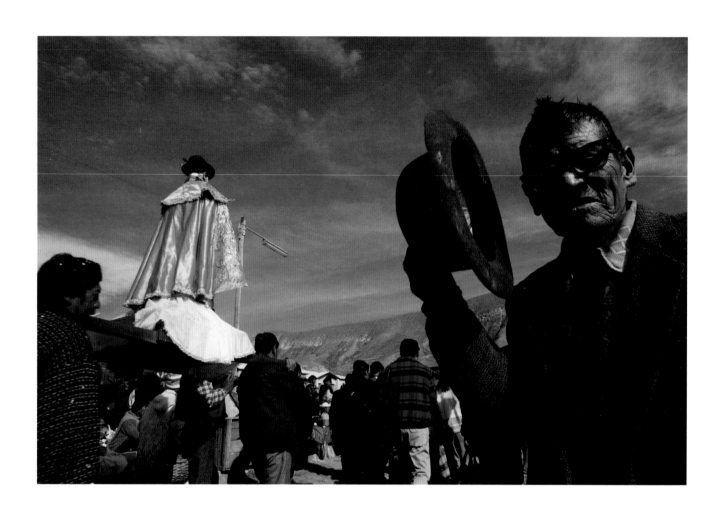

Procession of San Bartolomé, La Puerta.

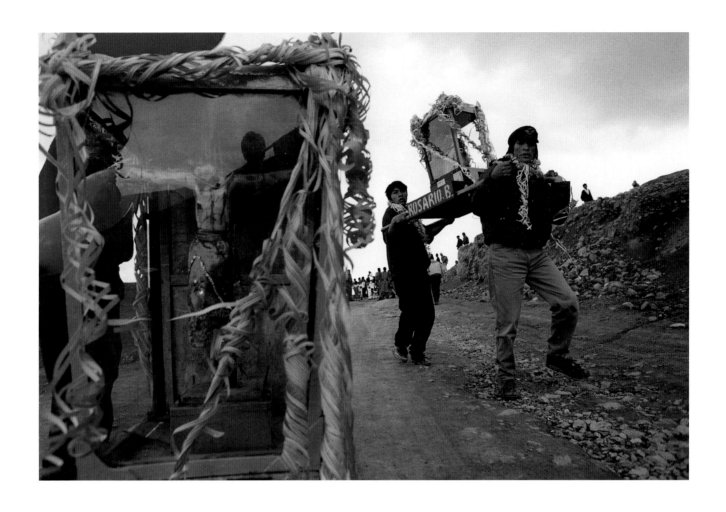

Miners Carnival.

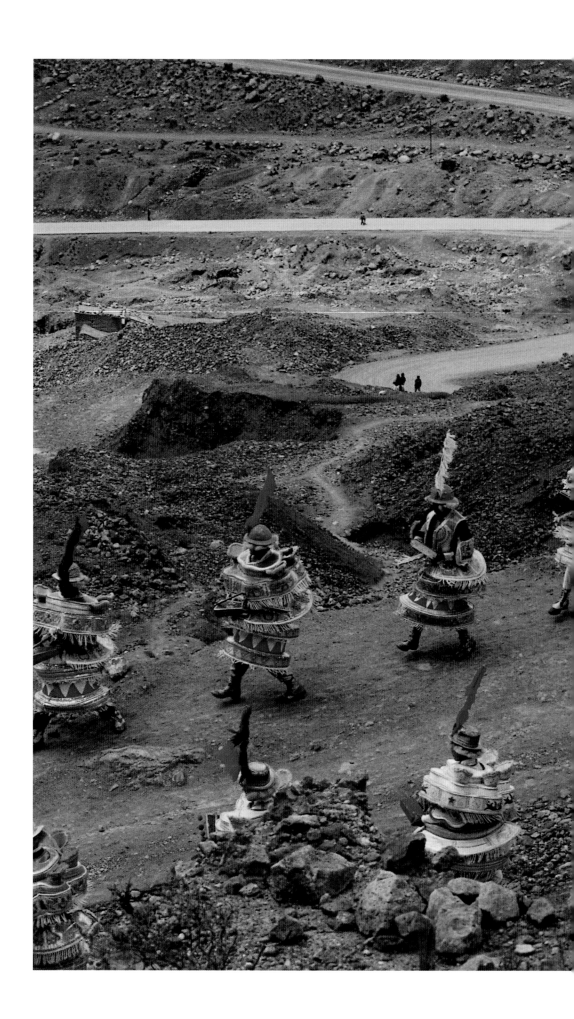

Morenada dancers,
Miners Carnival.

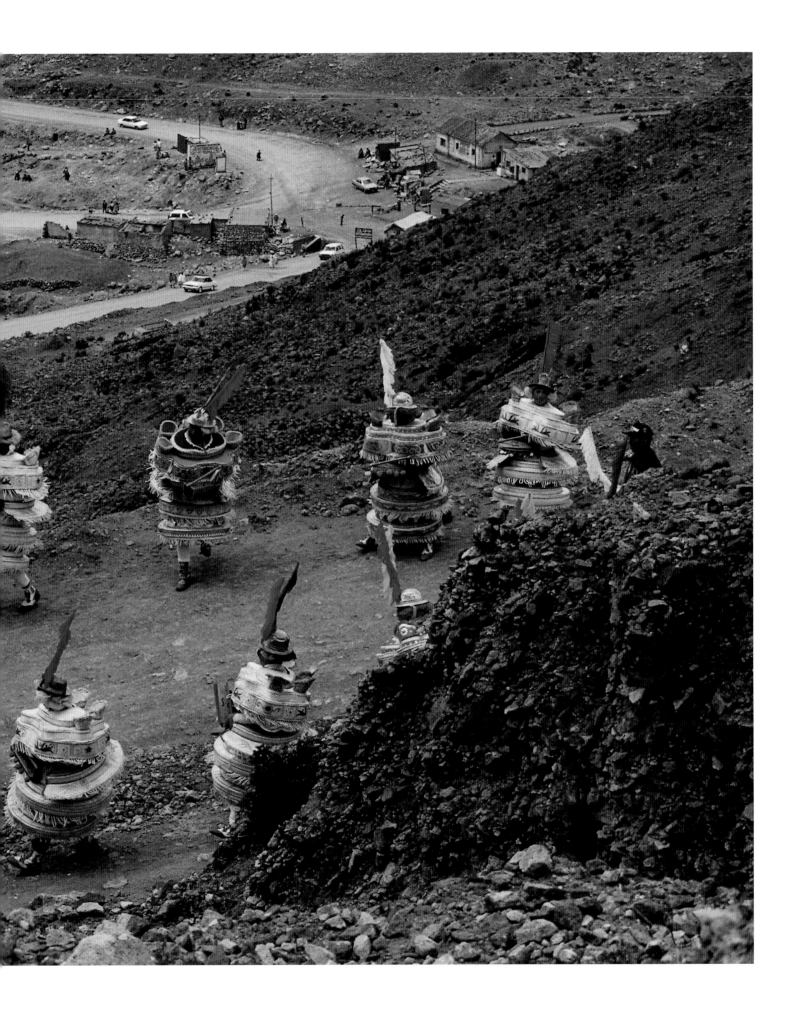

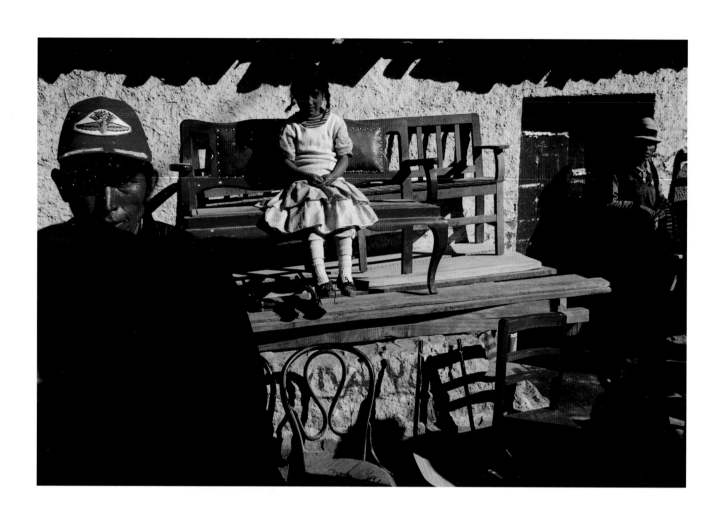

Onlookers, Ch'utillos.

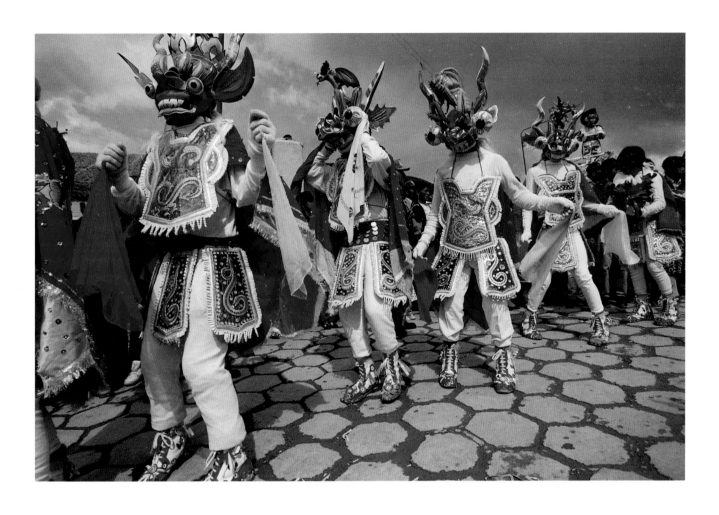

Dance of the Devil, Miners Carnival.

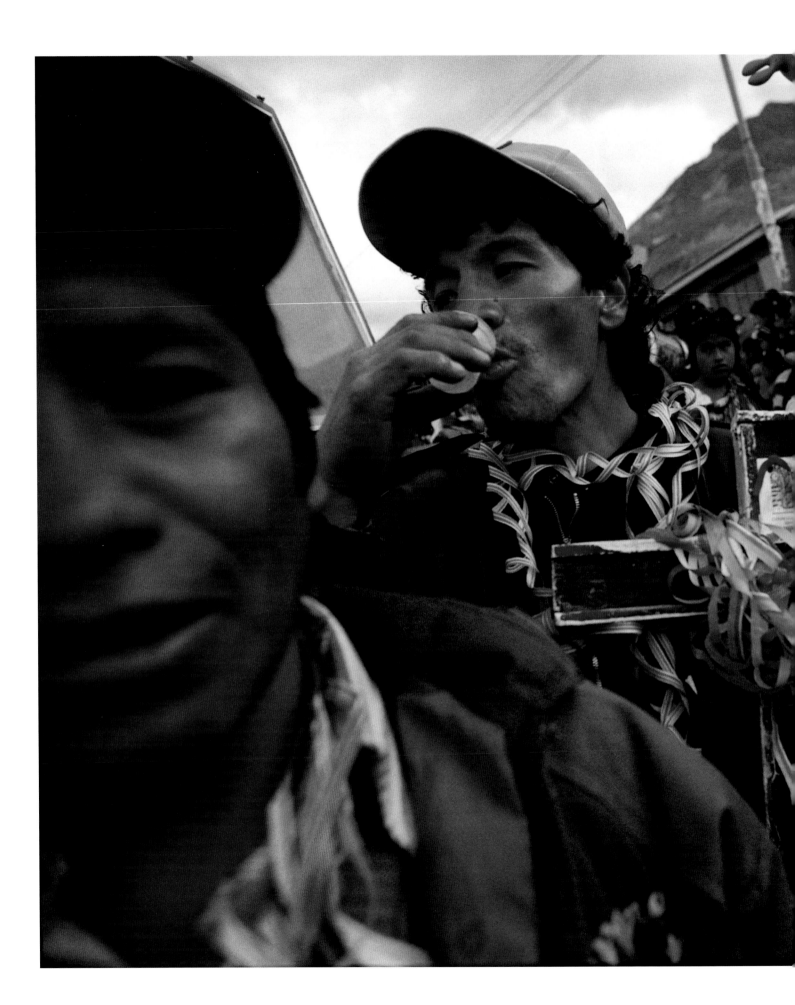

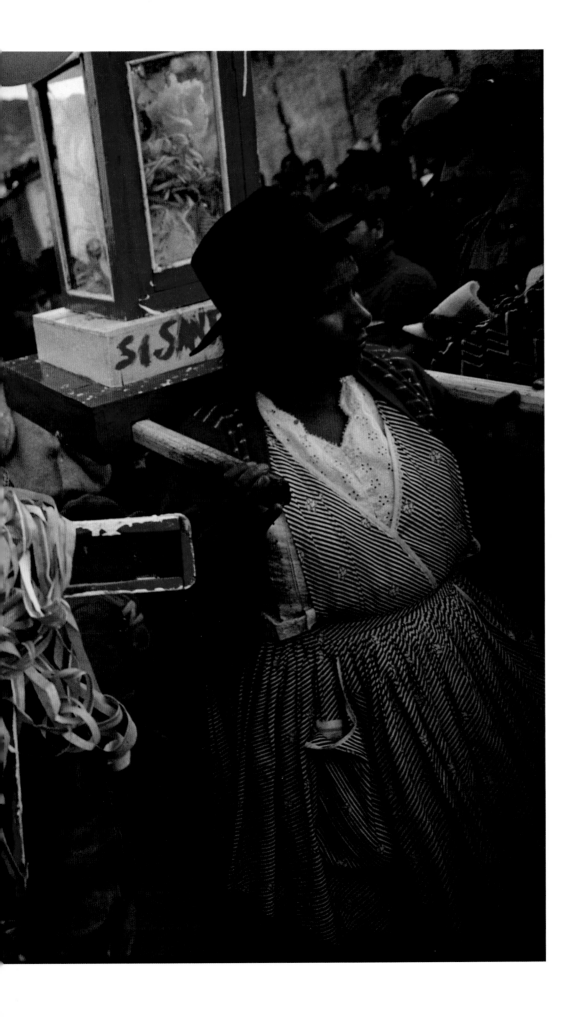

Grain alcohol, Miners Carnival.

La Puerta.

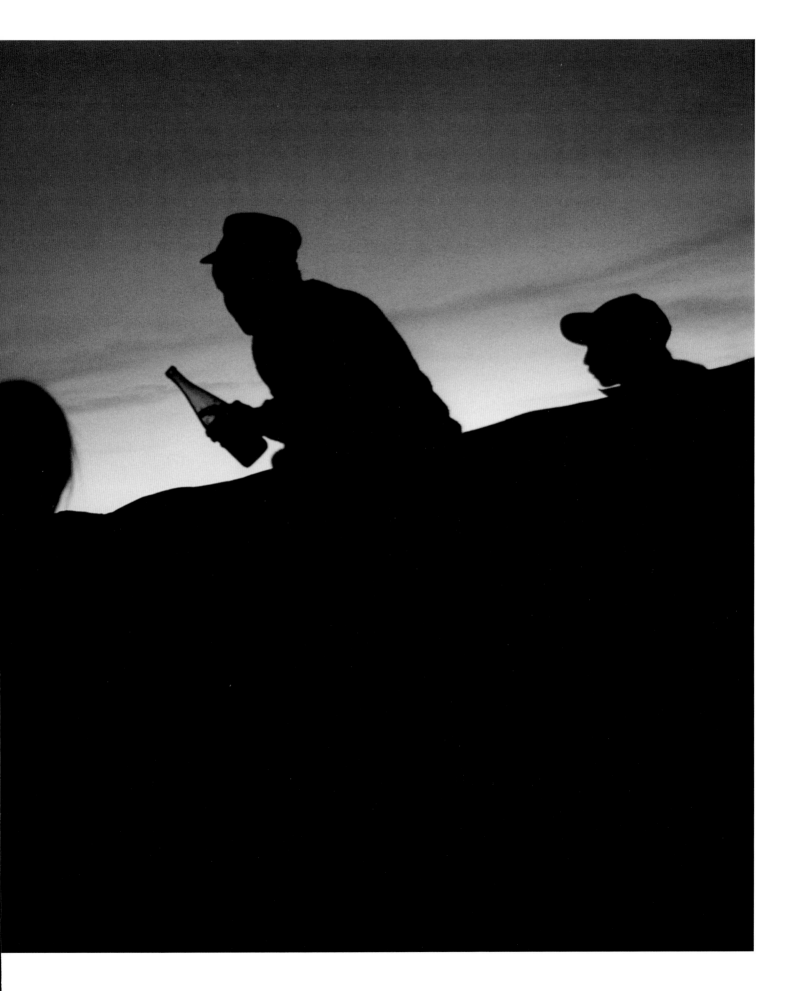

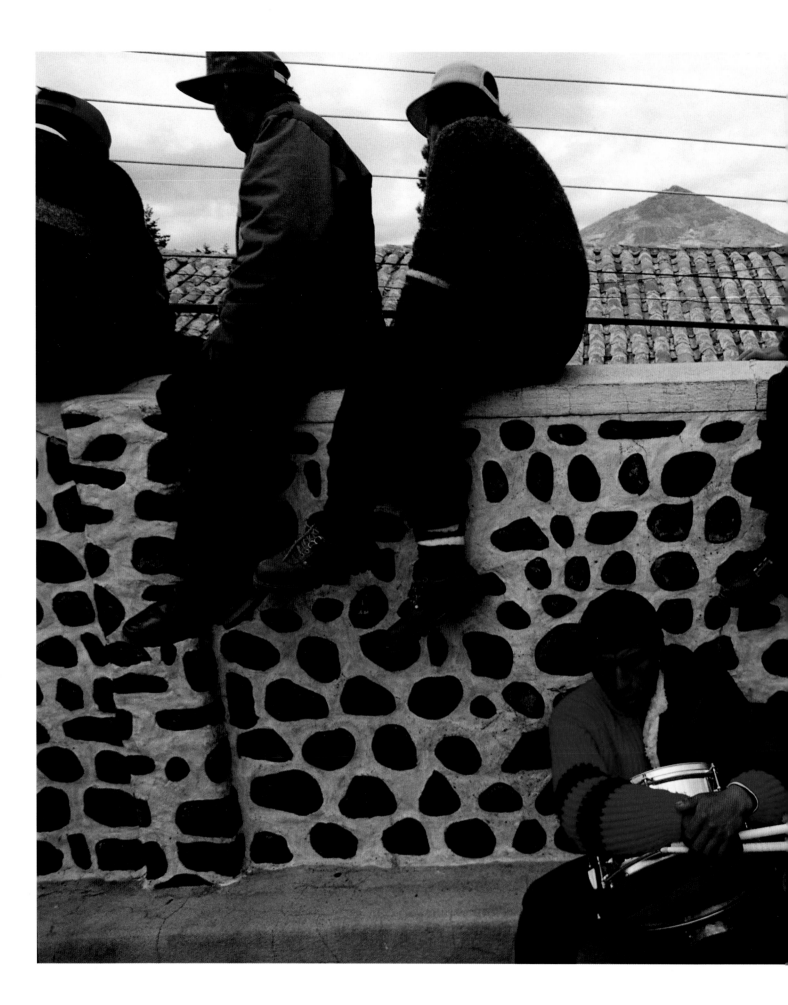

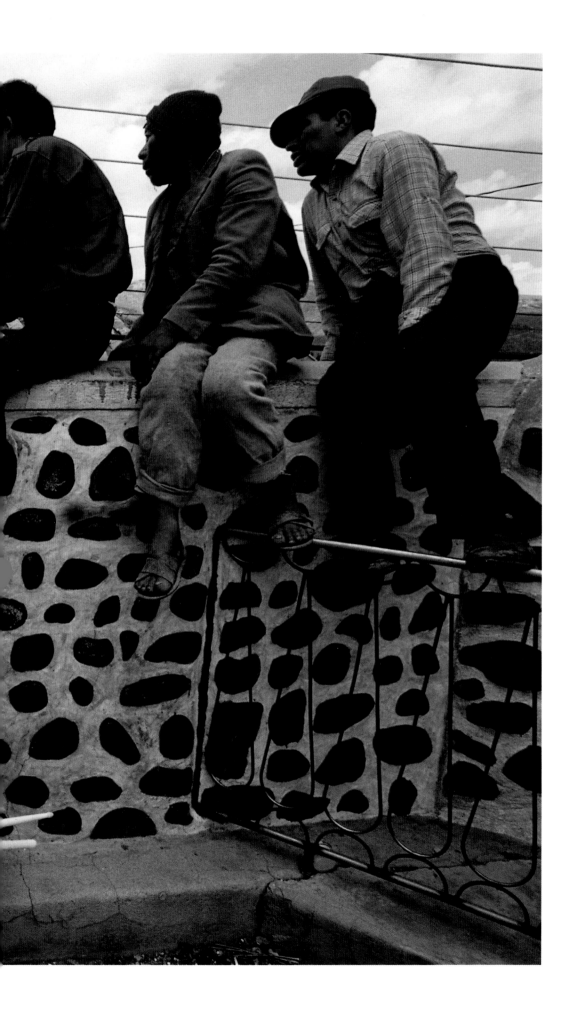

Miners Carnival.

The Imperial City of Potosí

1668: This same year the diminishment of the grandeurs of Potosí began; although they continued, they were not with the same pomp and brilliance as before; and so that you learn something of that grandeur up to this year, when they began to diminish, I say that gold, silver, pearls, and precious metals of such worth used to be so abundant that there was no limit to all of these... There were 72 establishments of very fine merchandise; and in each were found 200, 300, 400 thousand pesos of rich fabrics and noble materials; 140 stores of clothing . . . and 360 stores of provisions by which innumerable Spaniards enriched themselves, earning in only ten years 50, 80, at times 100 thousand pesos.

—BARTOLOME ARZANS DE ORSUA Y VELA,

THE ANNALS OF POTOSI, 1705

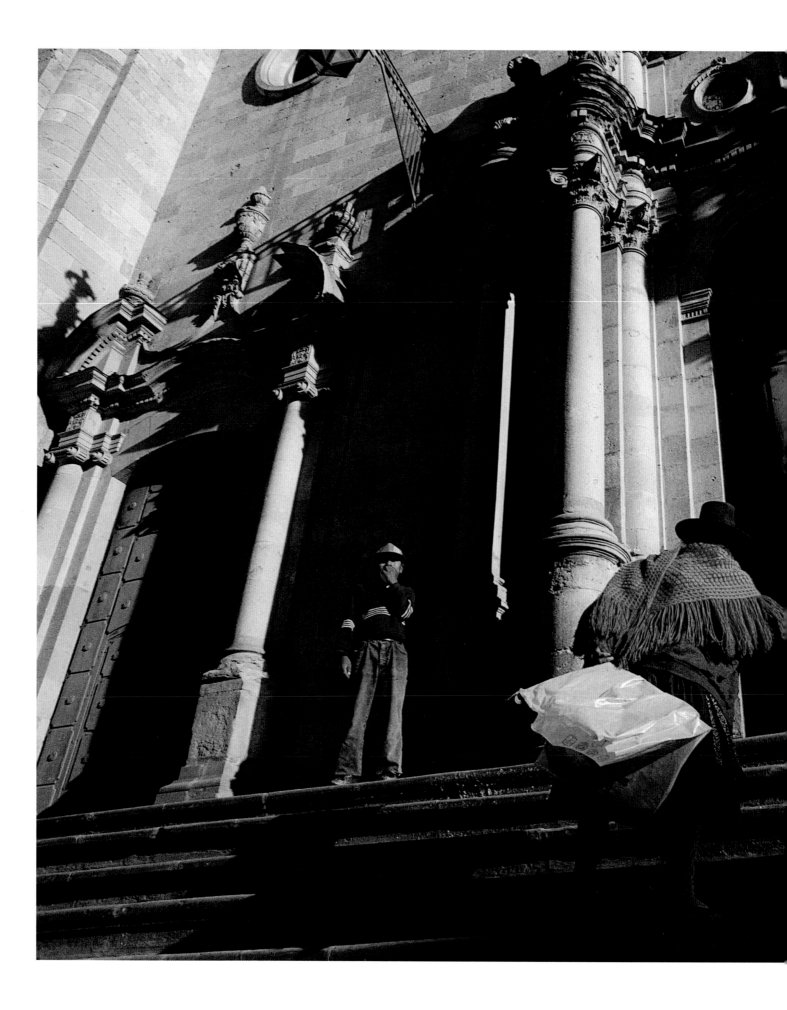

Cathedral of San Francisco.

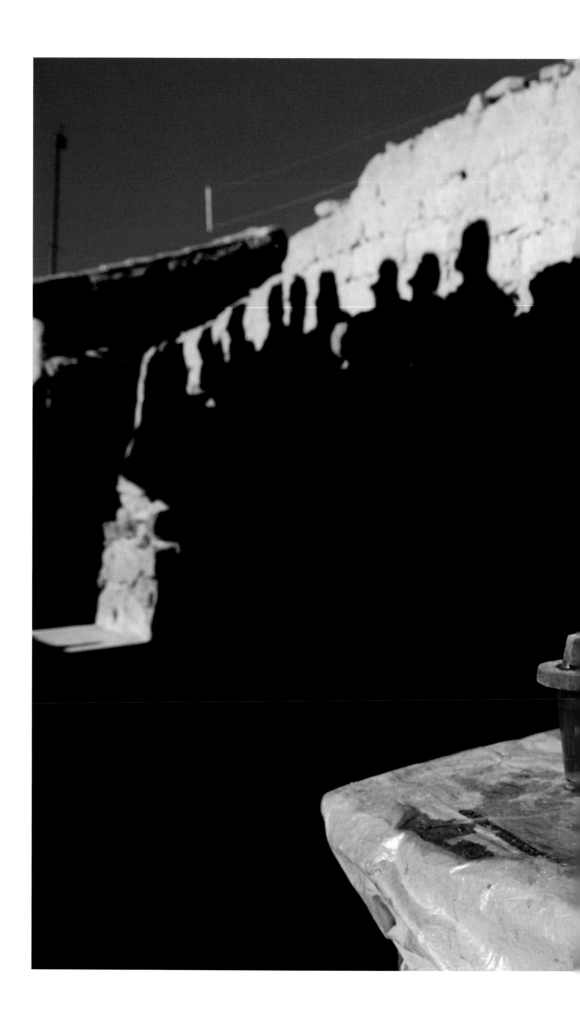

Miners, Calvario market.

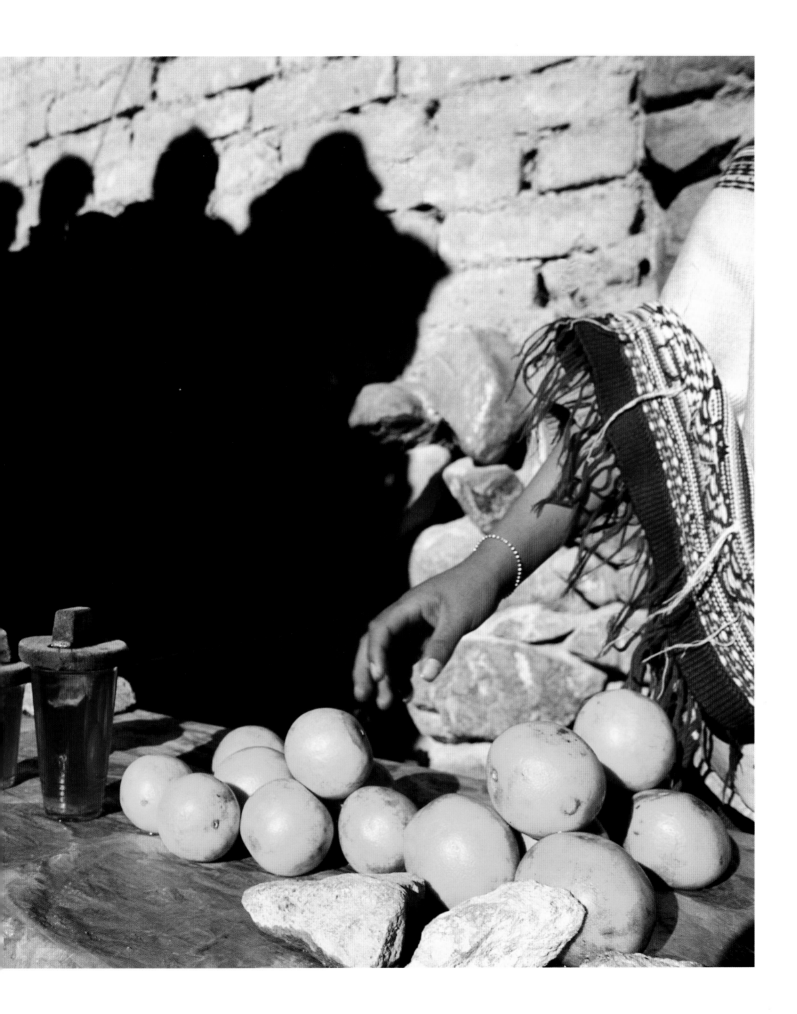

Calvario.

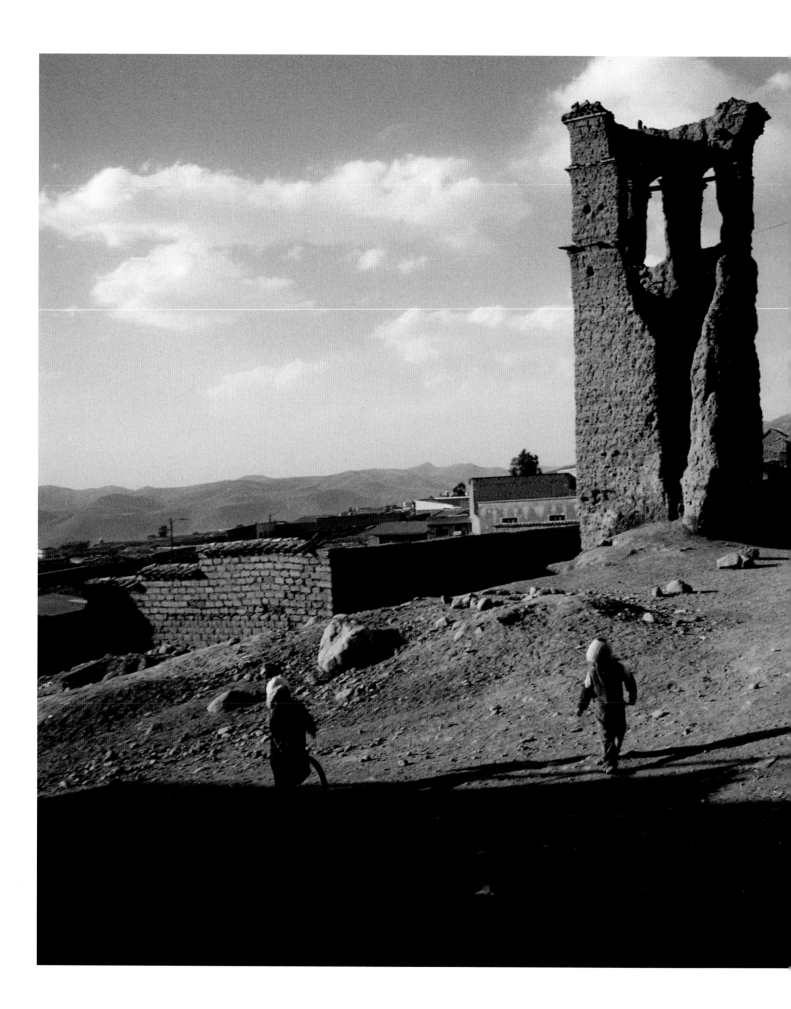

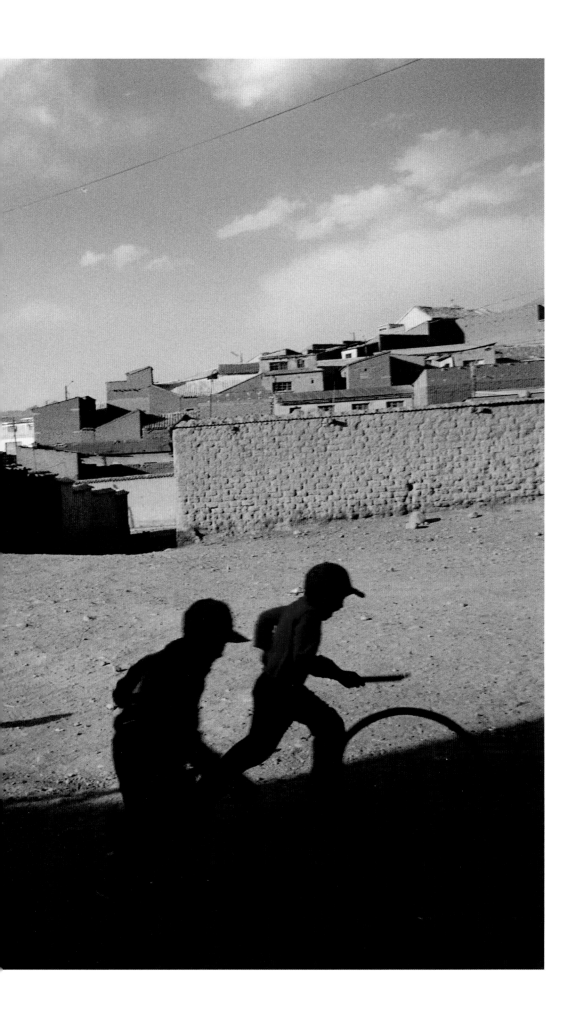

Calvario.

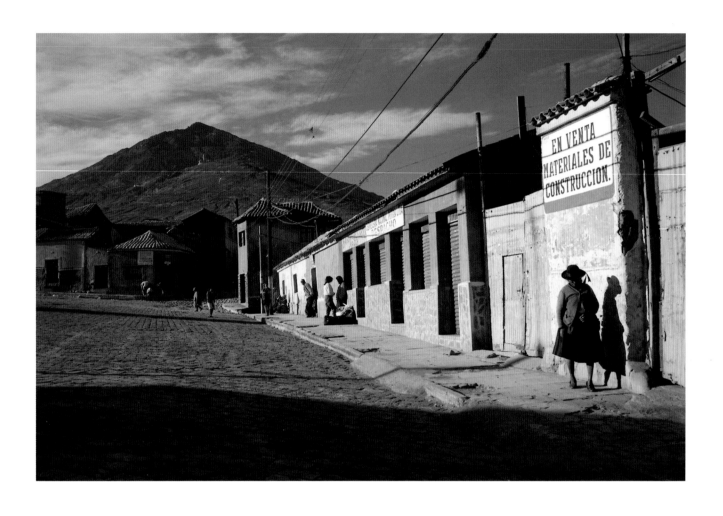

Plaza del Minero.

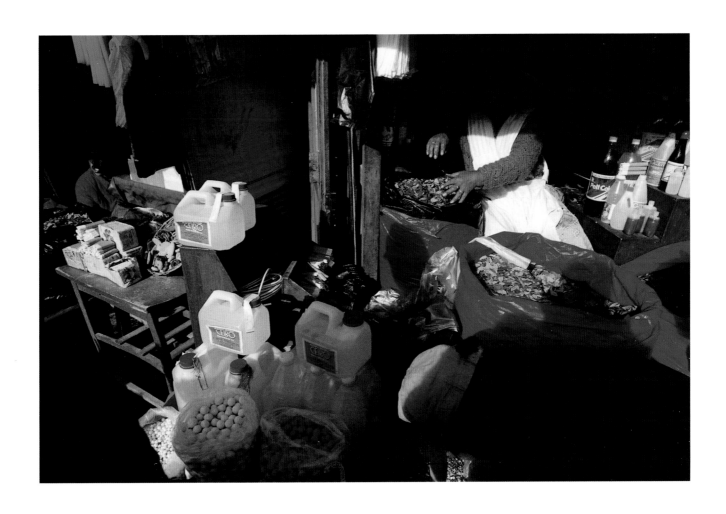

Coca leaf, Calvario.

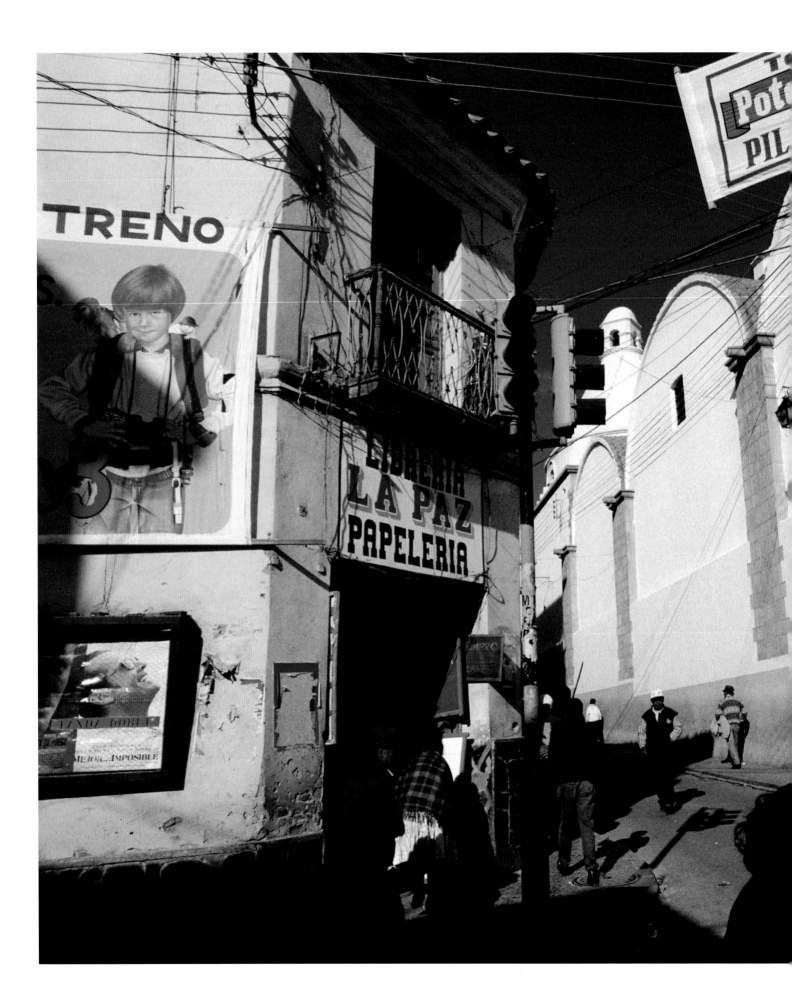

Colonial mint.

Plaza del Minero.

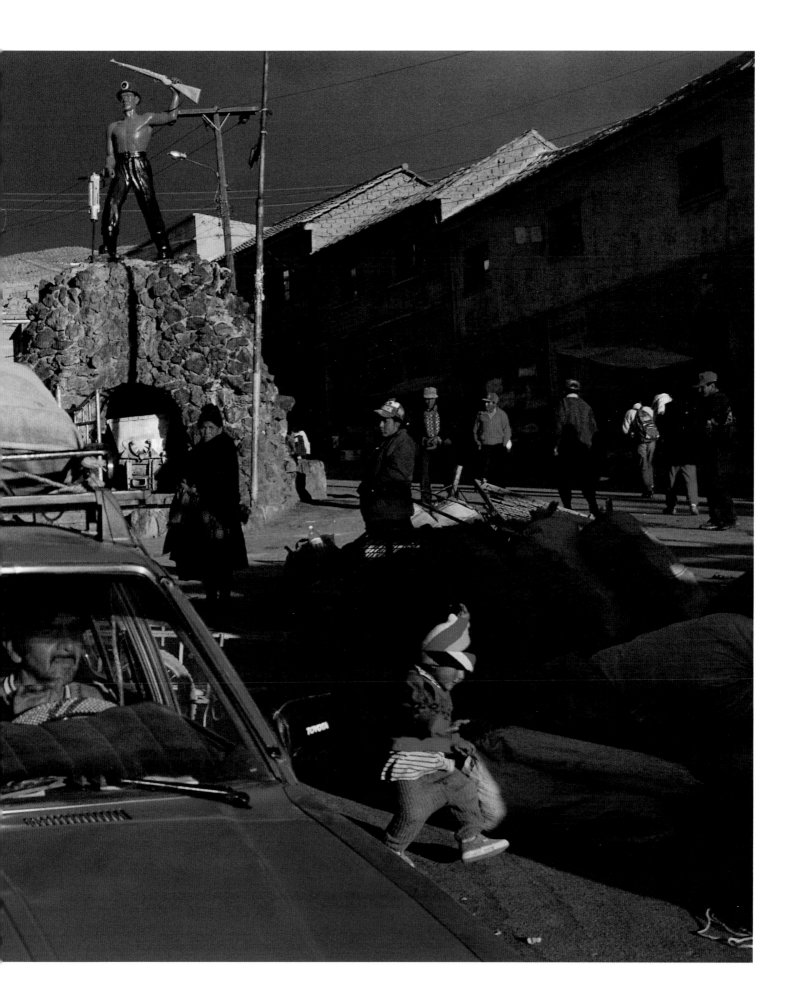

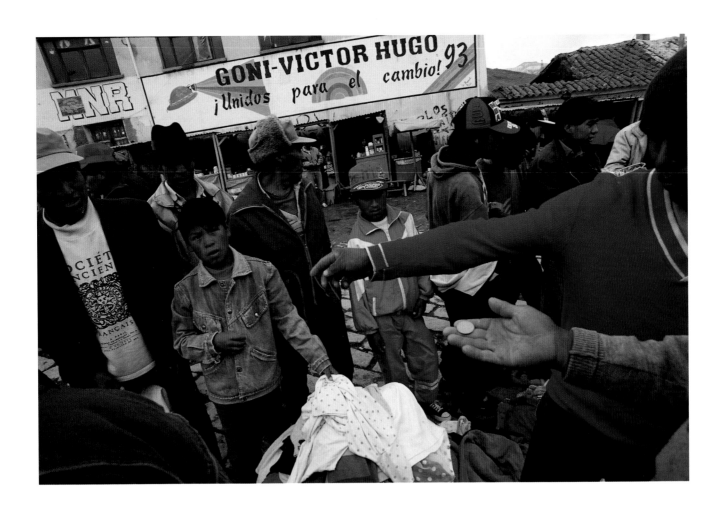

Calvario market.

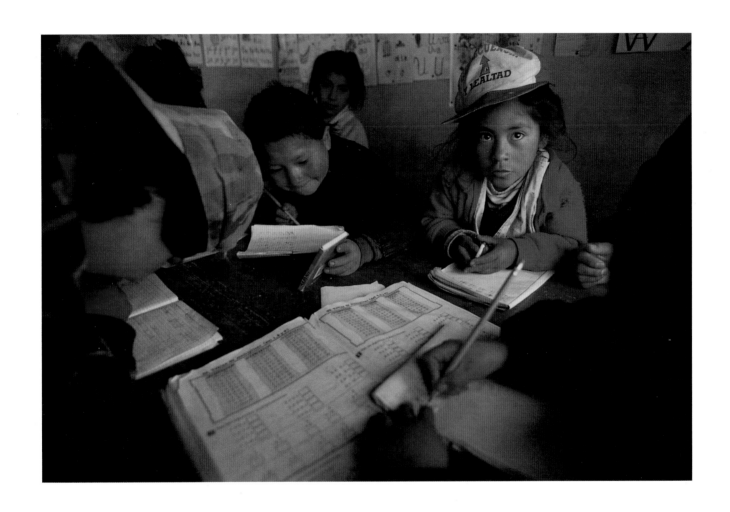

Palliri children.

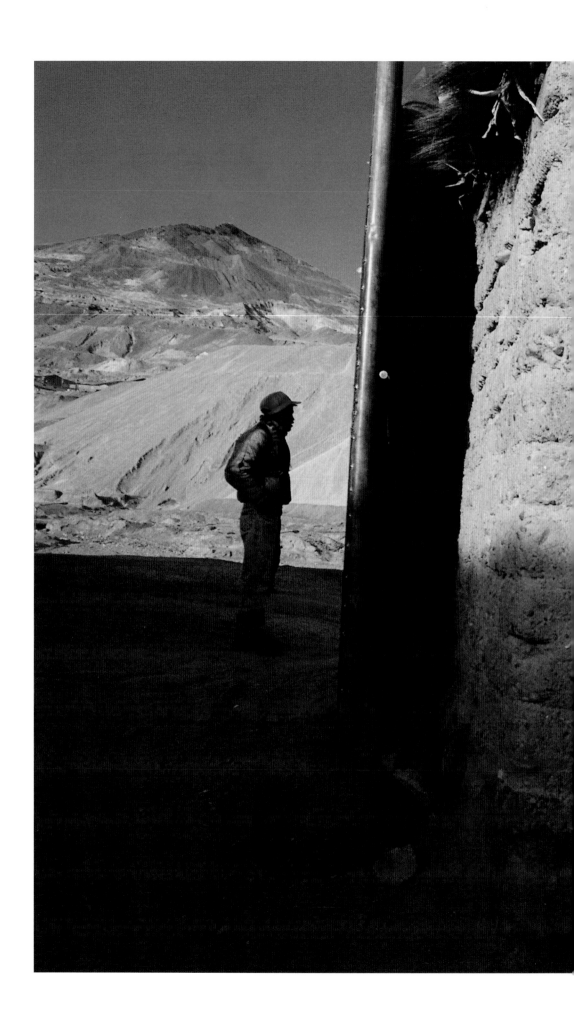

Morning, Calvario.

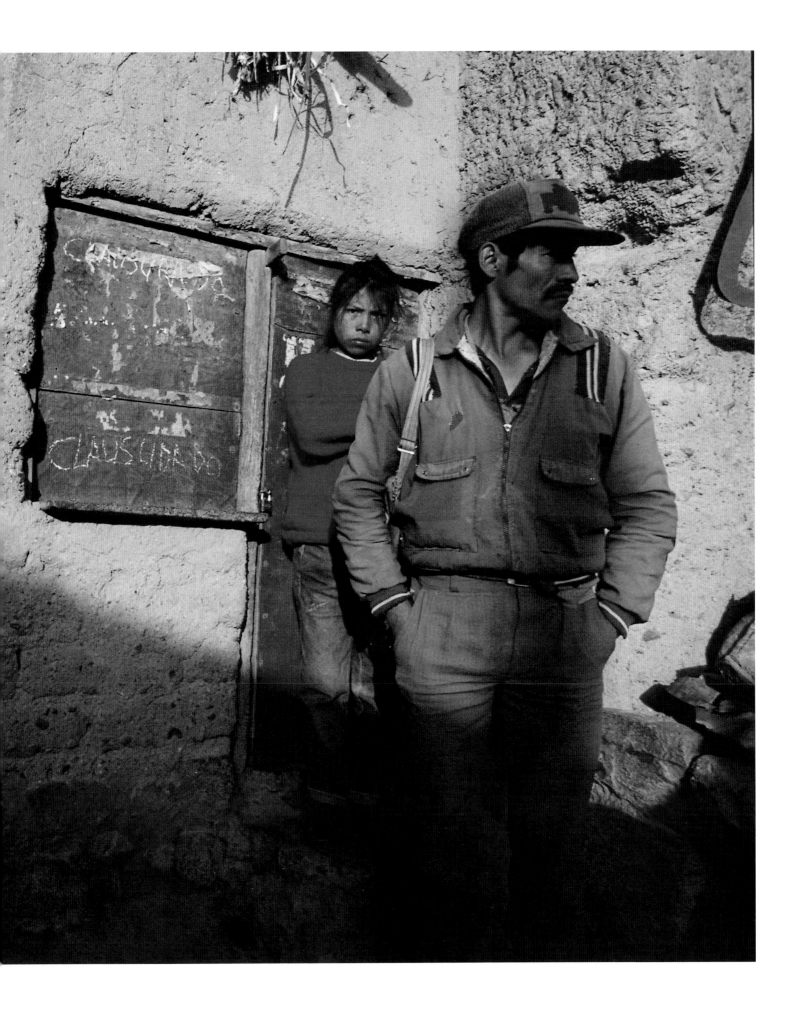

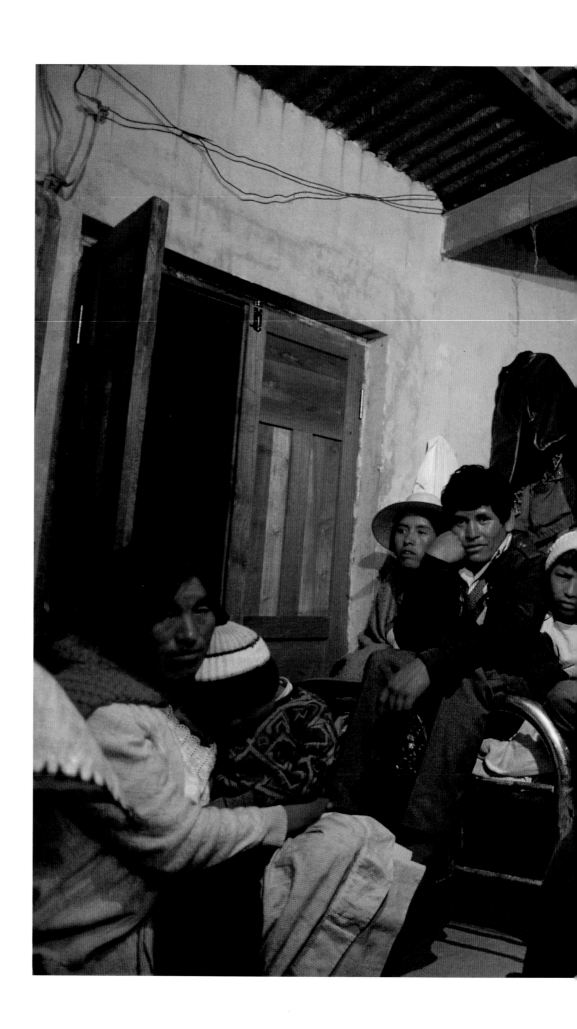

Miners' household, Calvario.

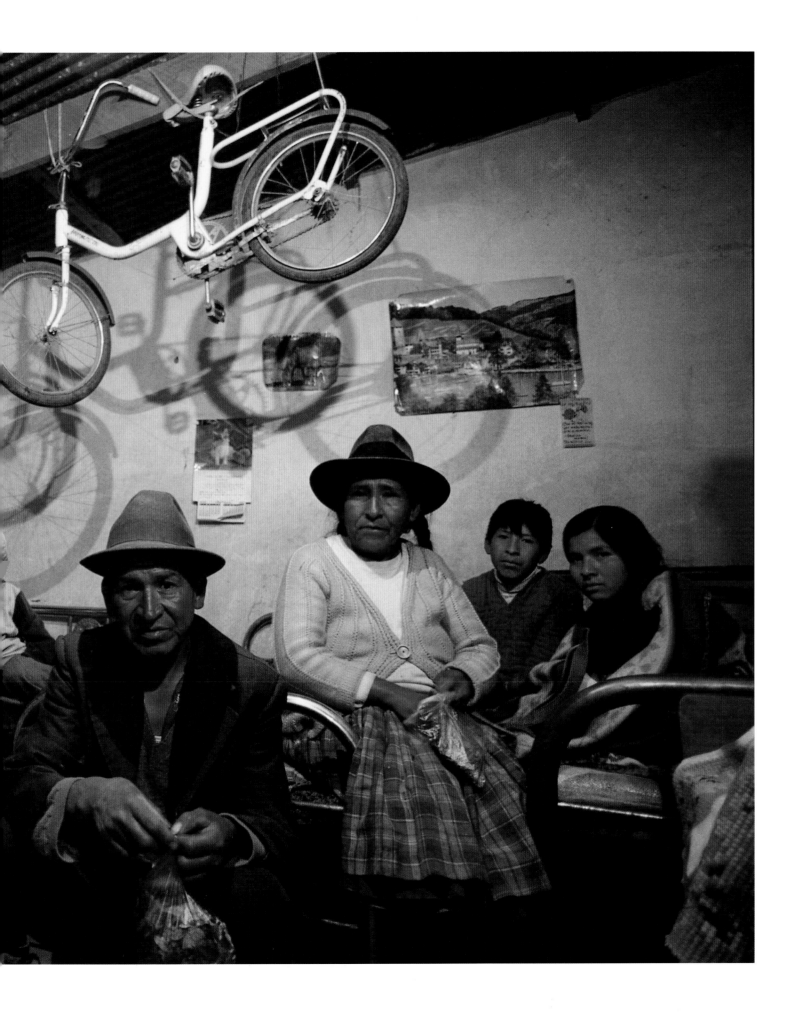

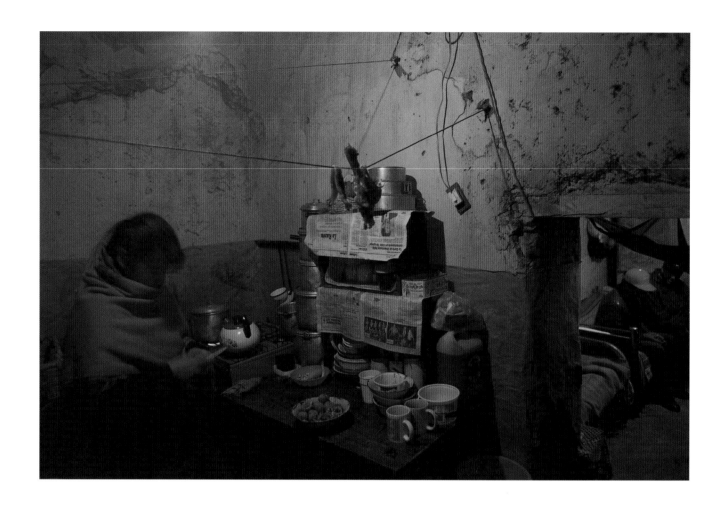

Calvario.

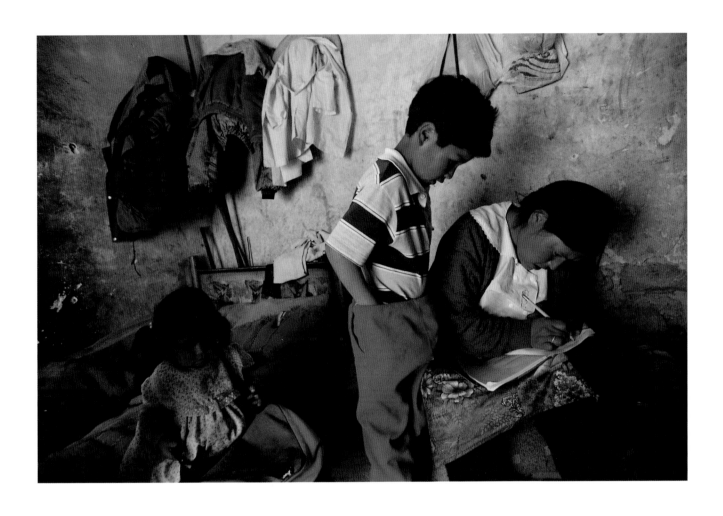

Guarda household, Santa Rita.

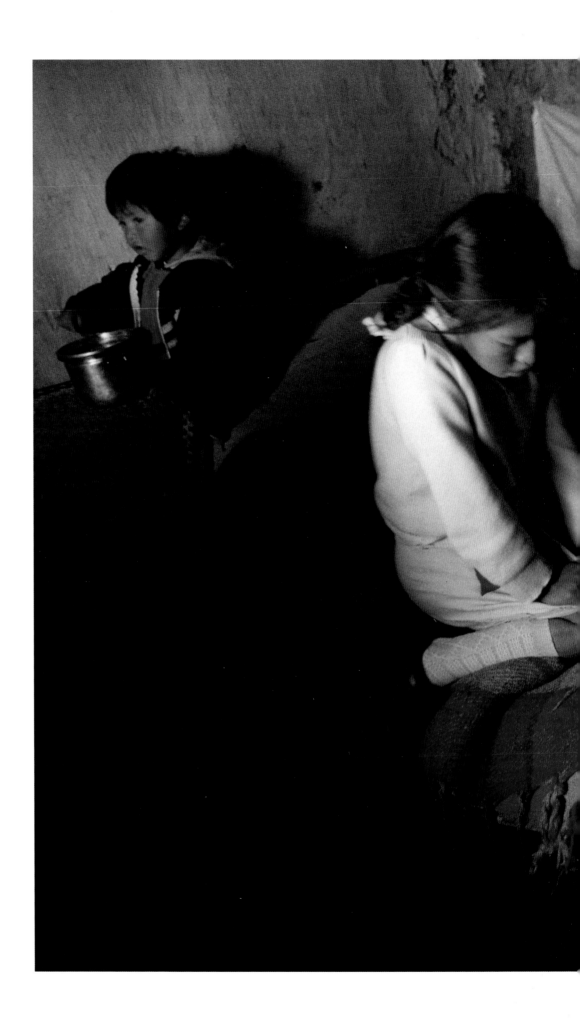

Morning, Calvario.

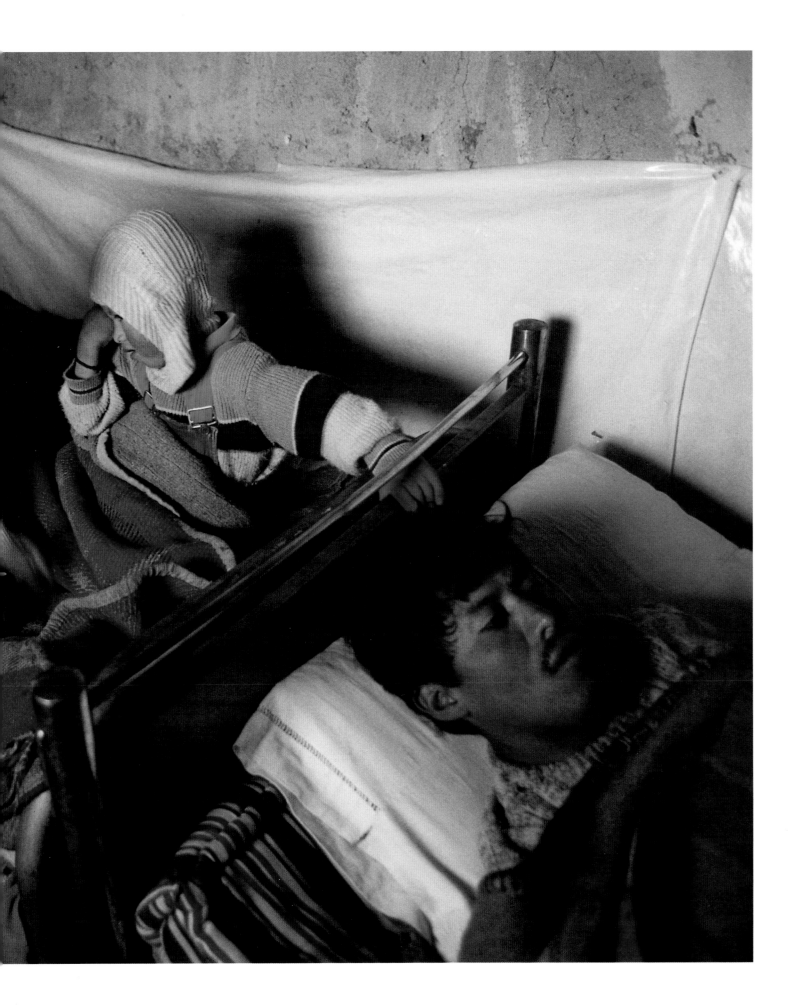

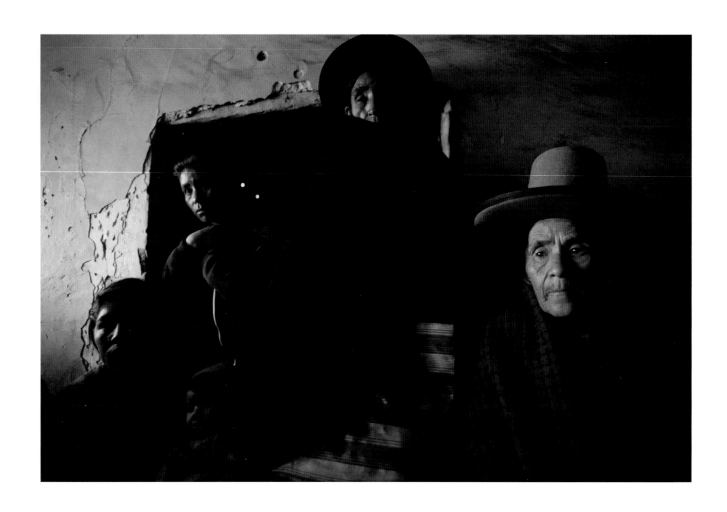

Meeting, Association of Palliris.

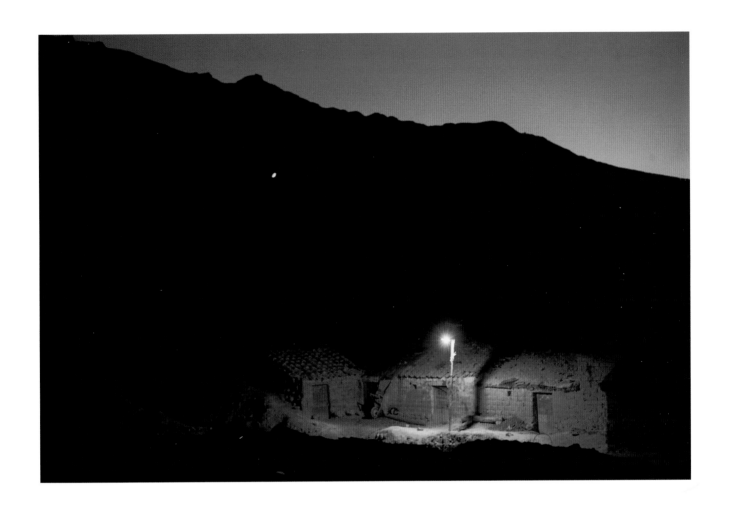

Guarda house.

Black Lung

The metal vapor they inhale breaks them down to such a degree that, along with these heavy tasks, and the copious sweat which the subterranean heat provokes and the excessive cold that they receive upon leaving the mine, they greet the dawn so languid and mortal that they appear to be cadavers.

—PEDRO VICENTE CANETE Y DOMINGUEZ,
CHRONICLES OF THE IMPERIAL CITY OF POTOSI, 1714

And so the hospital is full of Indians, and every day fifty die, because of this wild beast that swallows them alive.

—LUIS CAPOCHE,
GENERAL ACCOUNT OF THE IMPERIAL CITY OF POTOSI, 1585

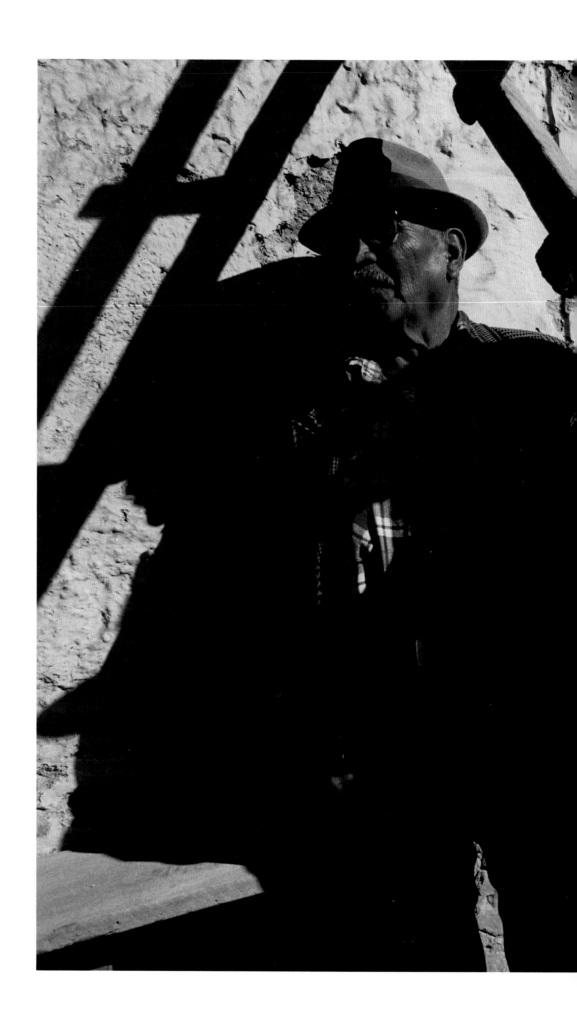

Sunday morning.

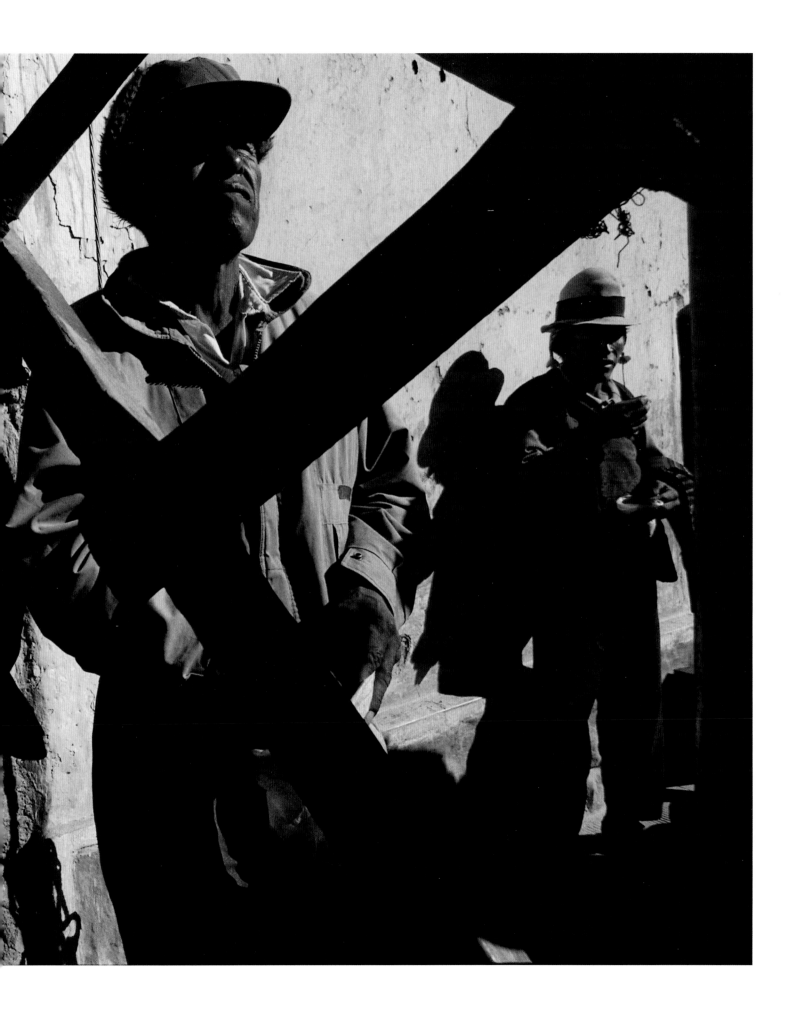

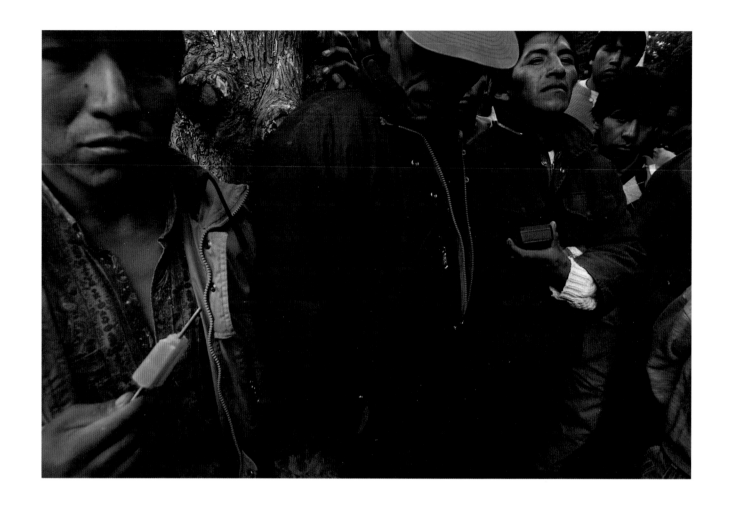

Strike.

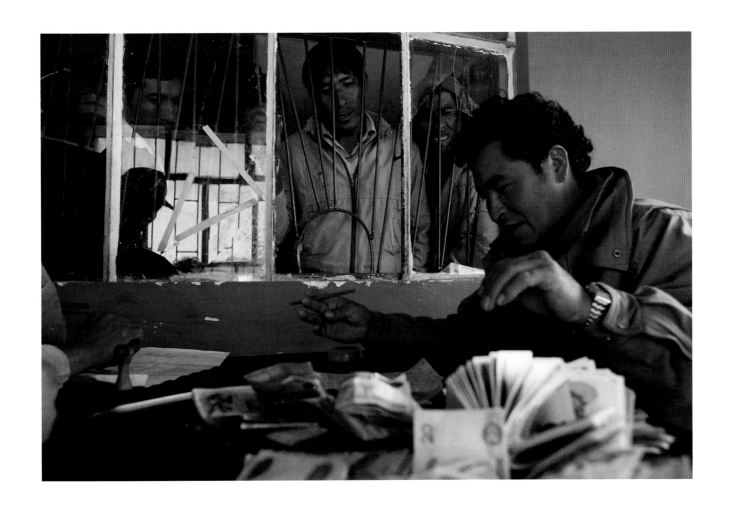

Payday, Unificada Cooperative.

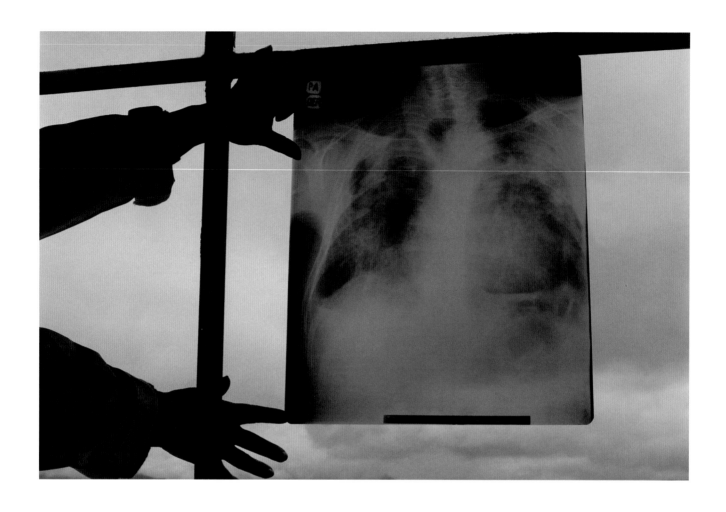

Silicosis, Caja Nacional Hospital.

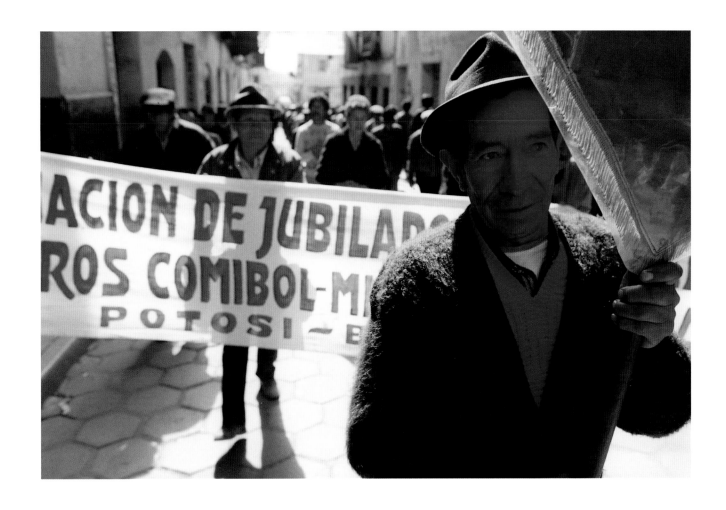

Protest by retired miners with silicosis.

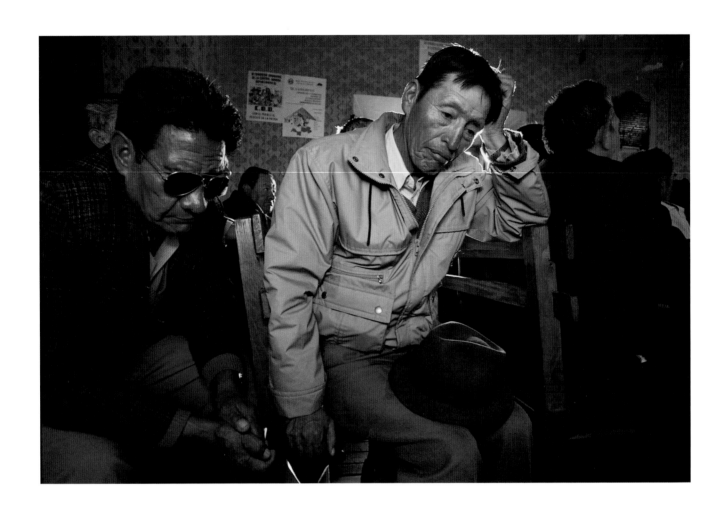

Meeting hall, Association of Retired Miners.

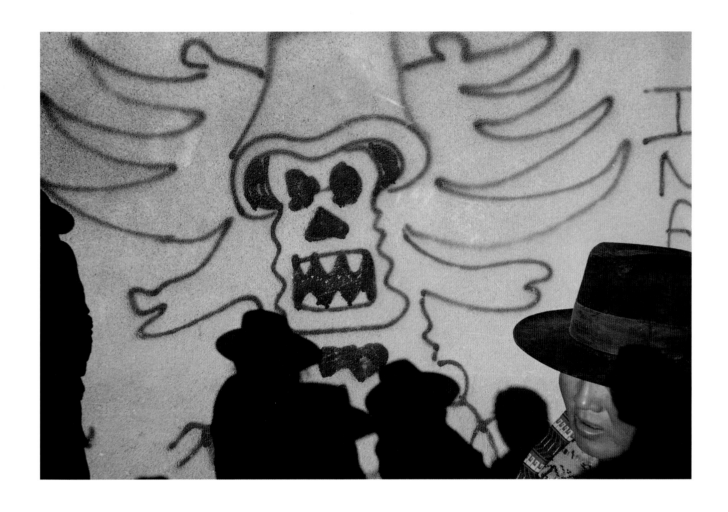

Uyuni market.

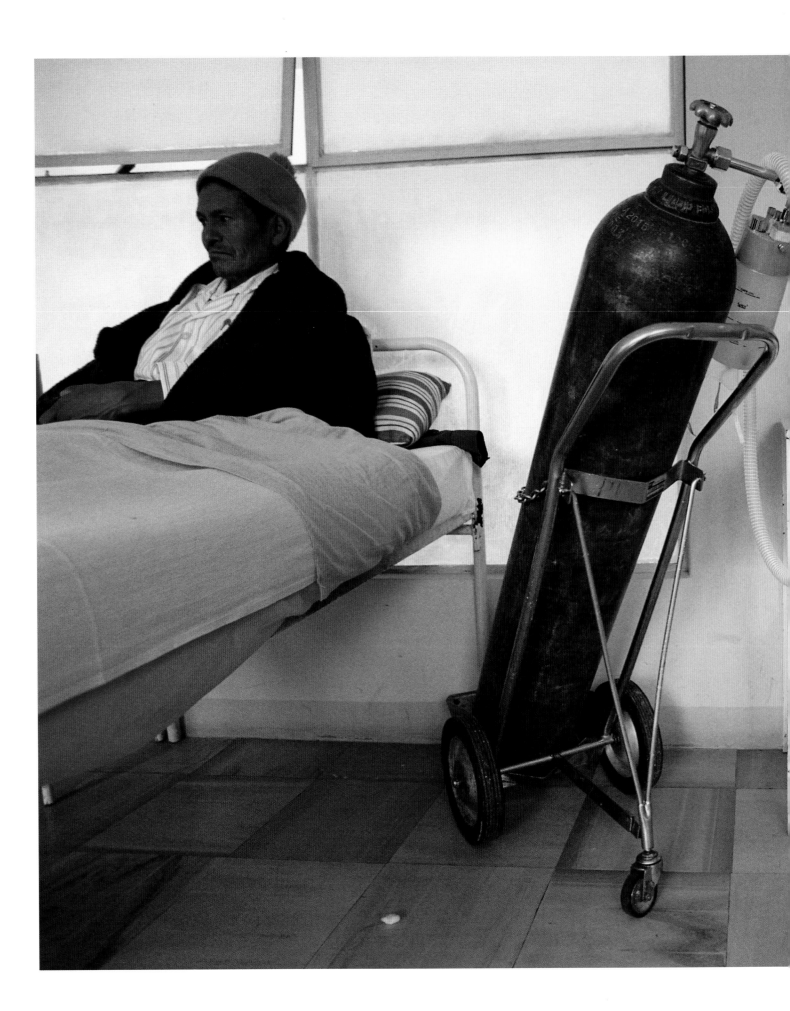

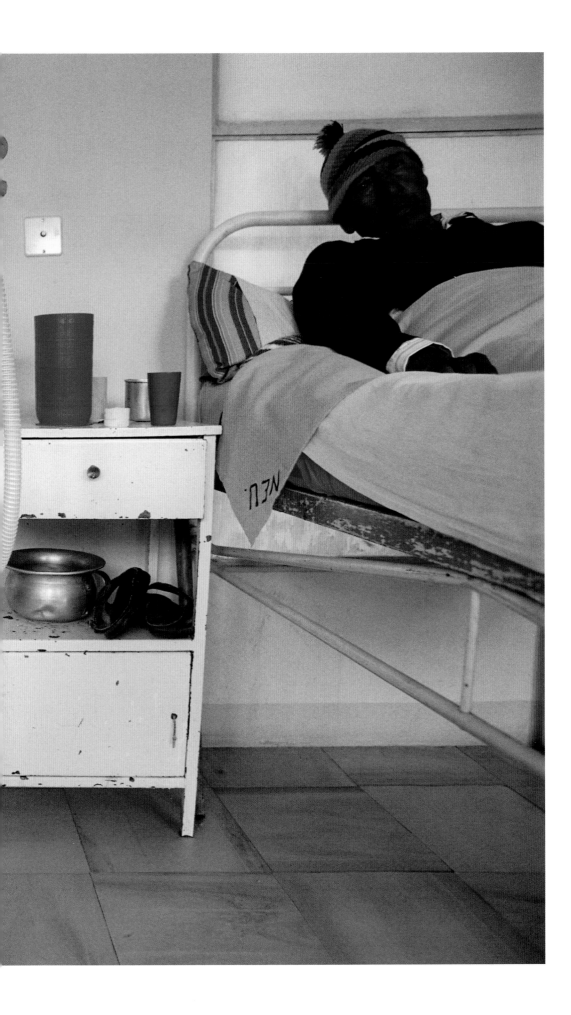

Caja Nacional Hospital.

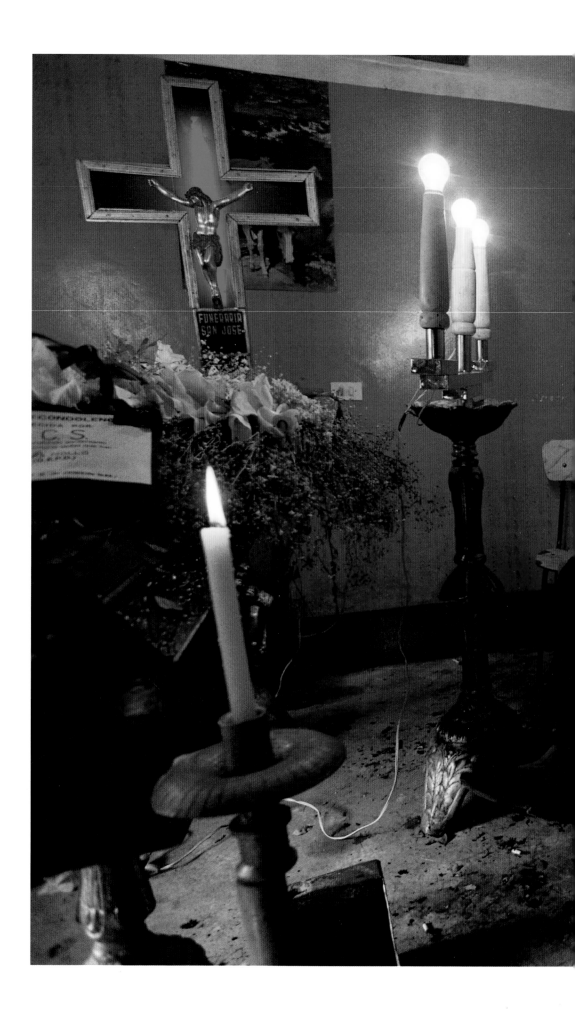

Wake.

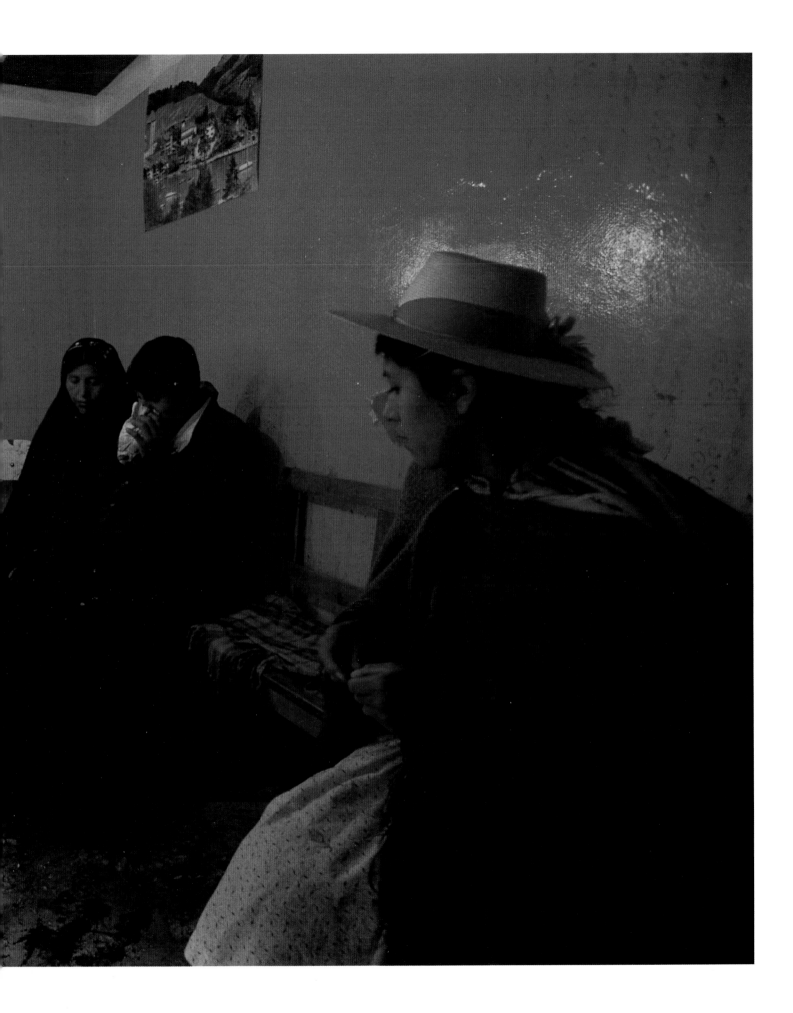

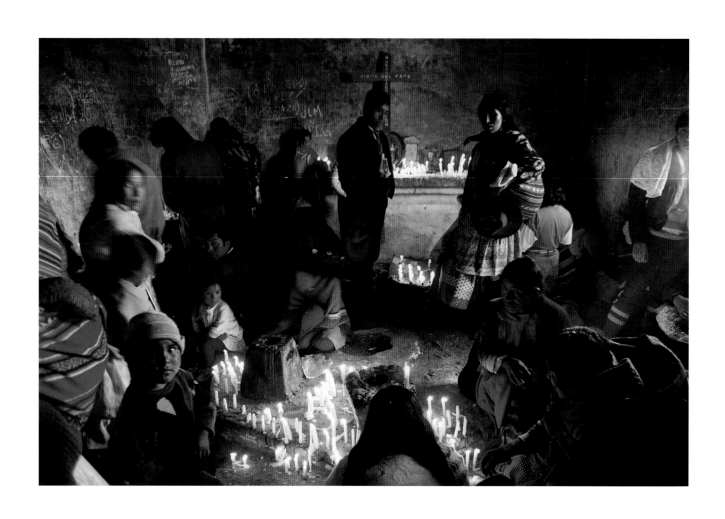

Chapel of Manquiri.

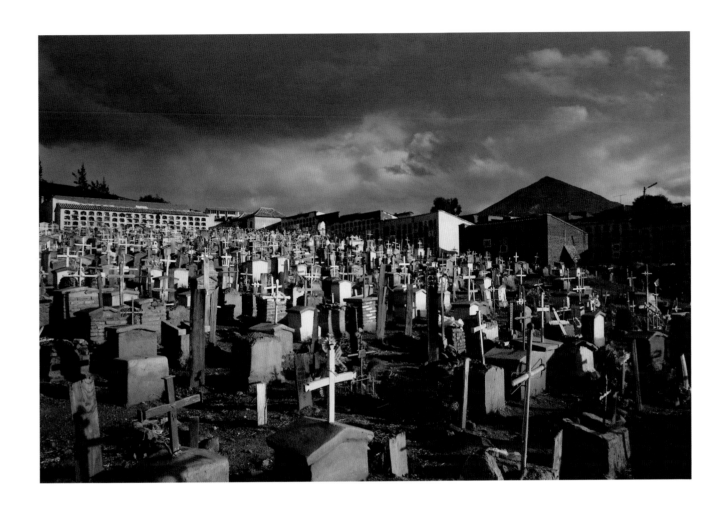

Sucre Cemetery.

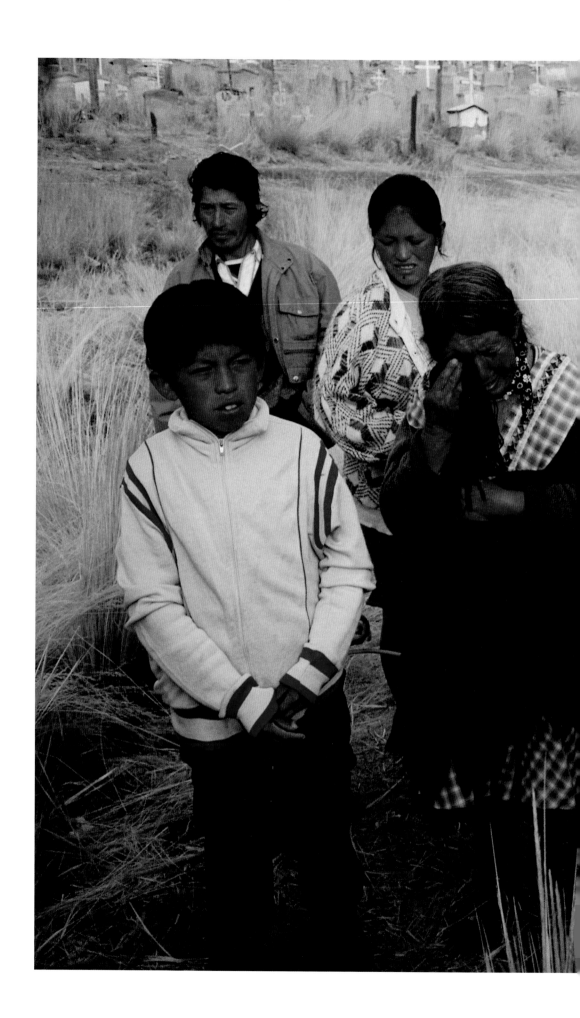

Sucre Cemetery.

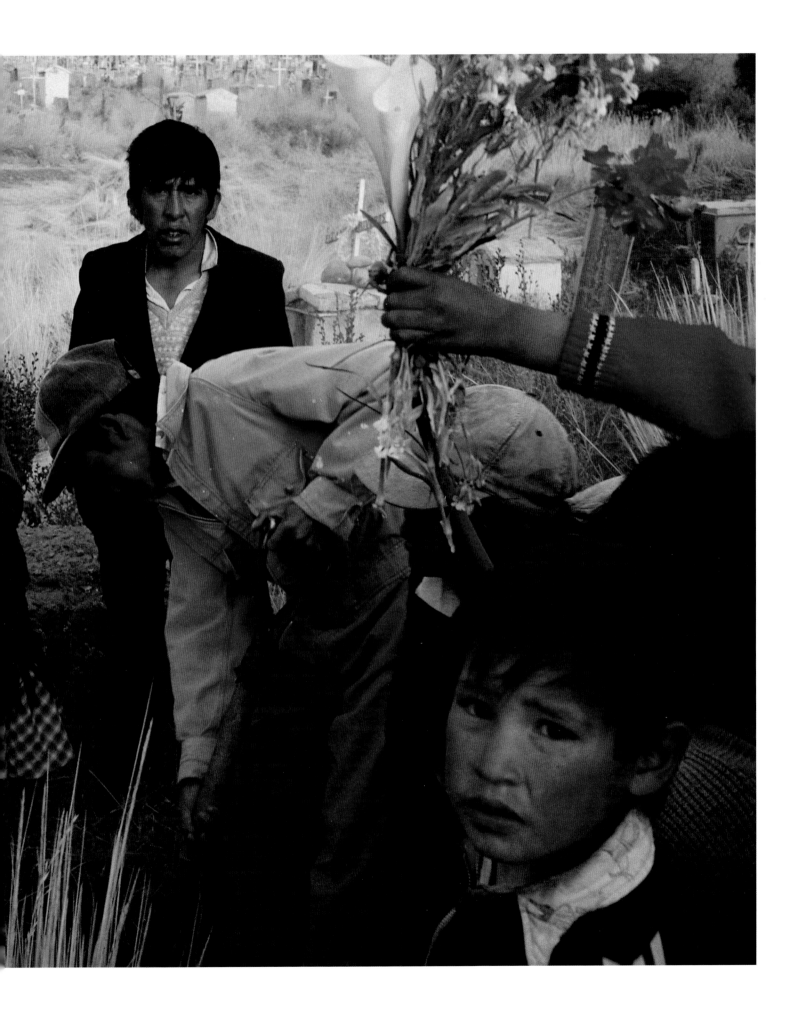

Sacrifice

We sacrifice to the devil, so he will not take our lives instead.

—MARIO BRAVO, ROSARIO BAJO MINESHAFT, 1994

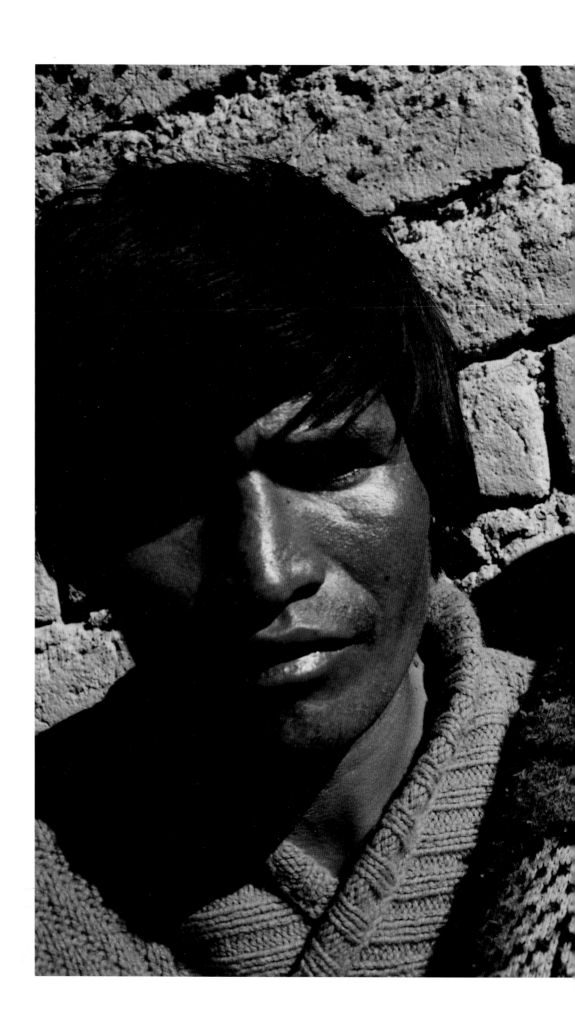

Espíritu sacrifice festival,
Caracoles mine.

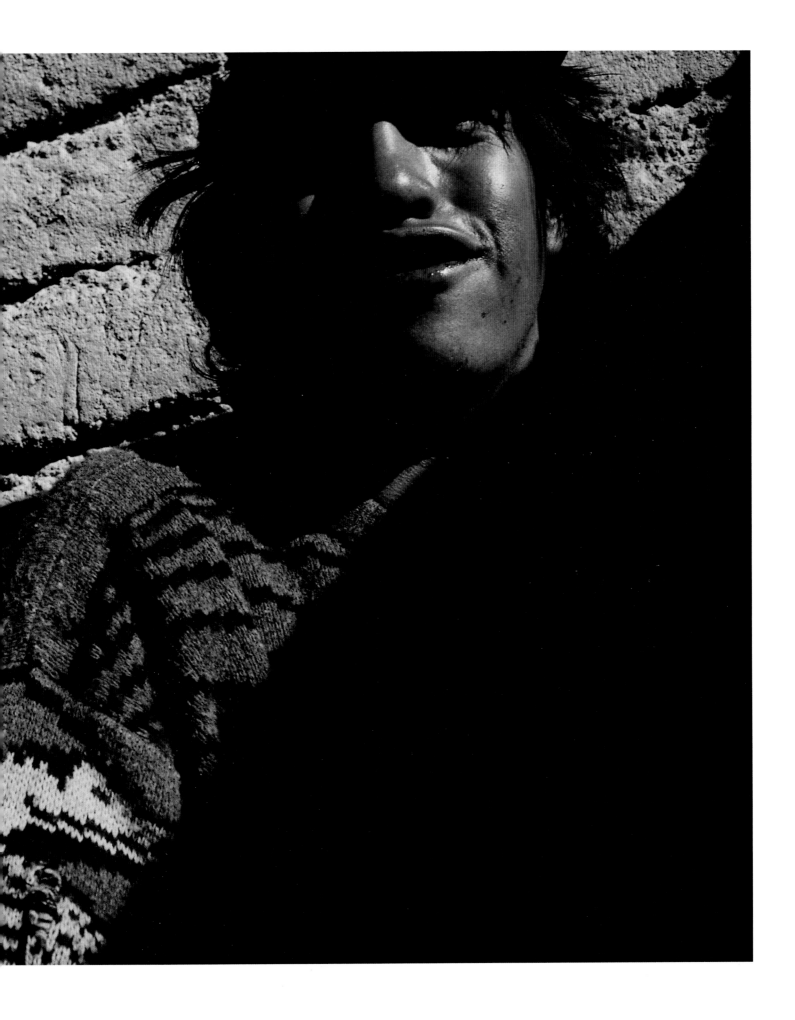

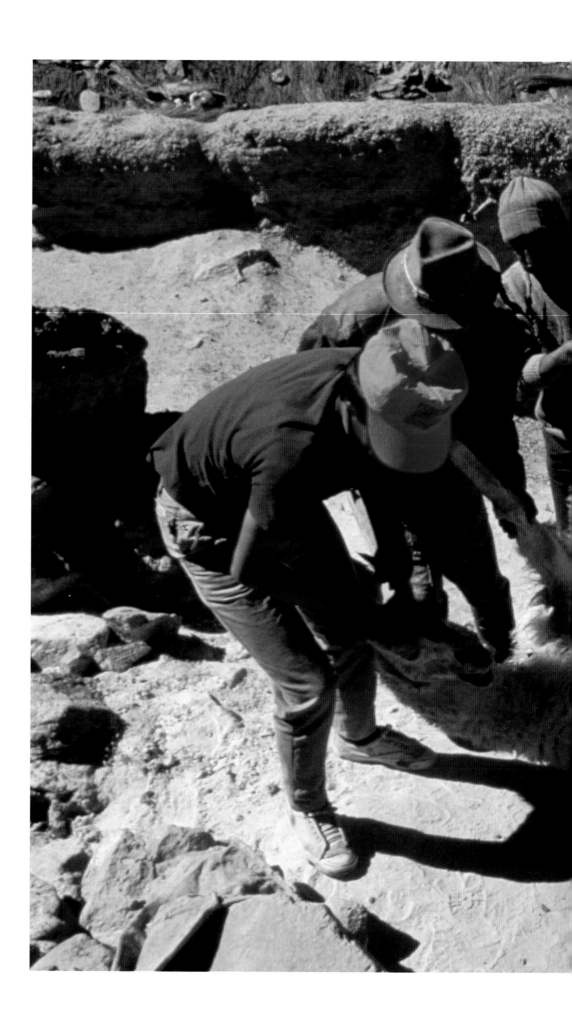

Llama, Espíritu festival,
Candelaria Baja.

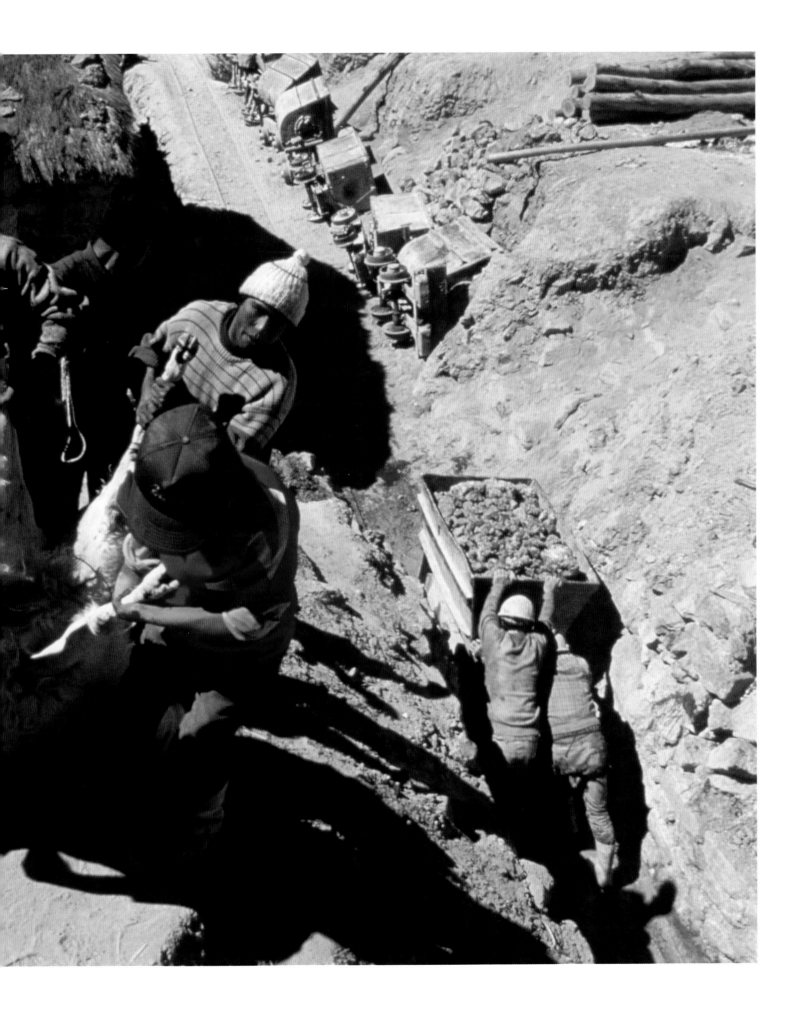

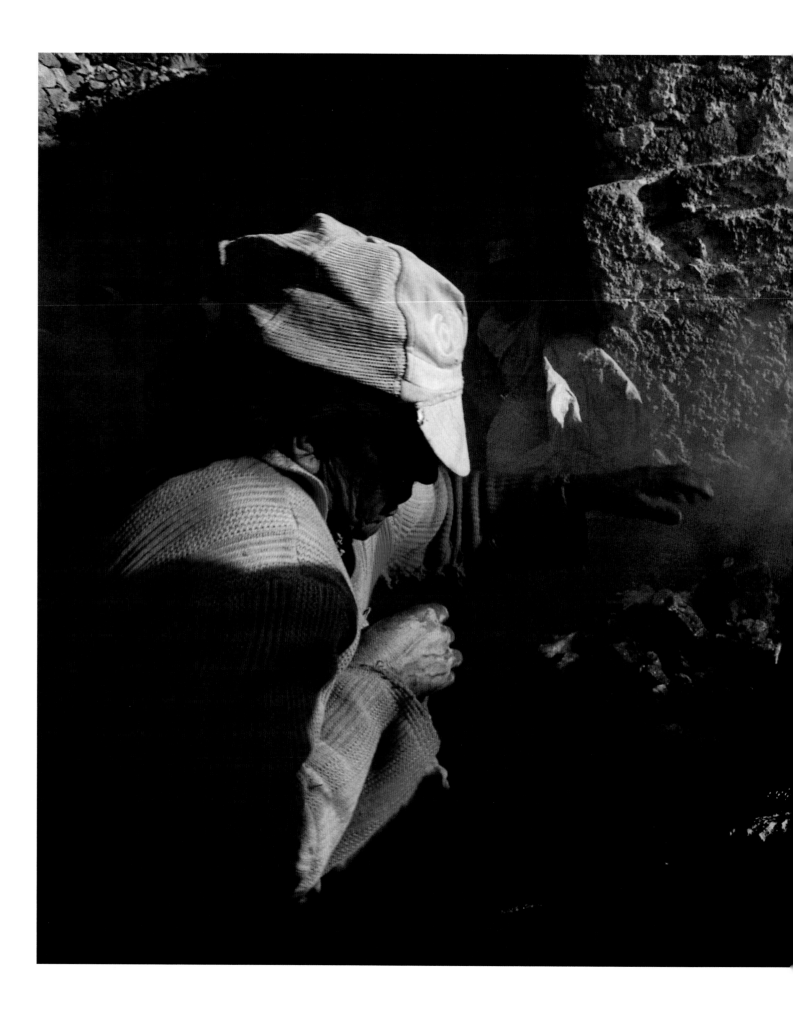

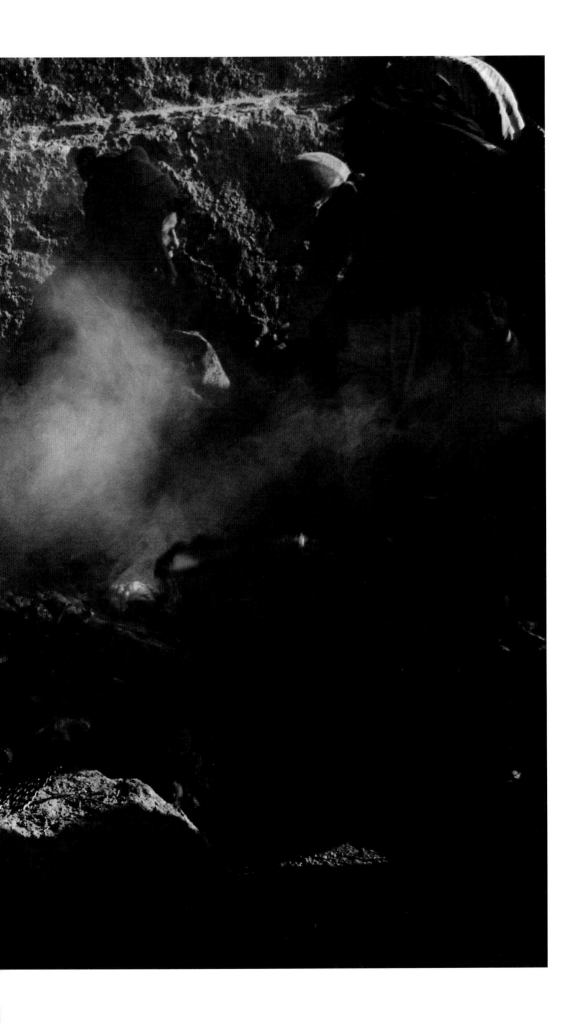

Caracoles.

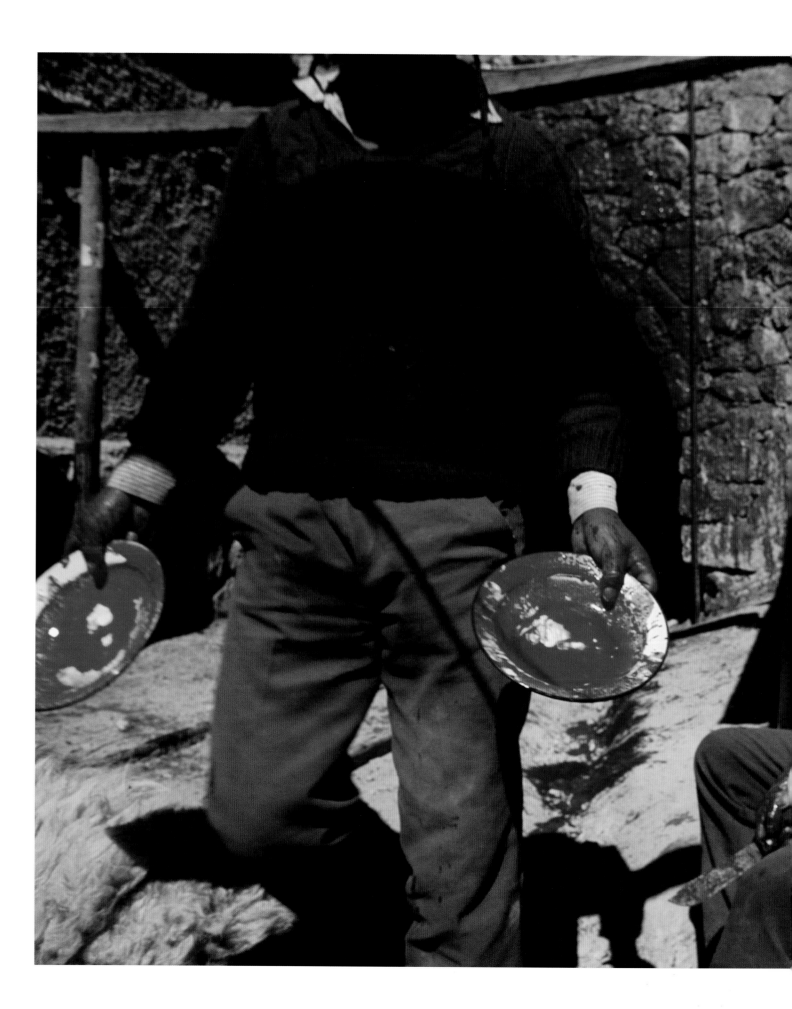

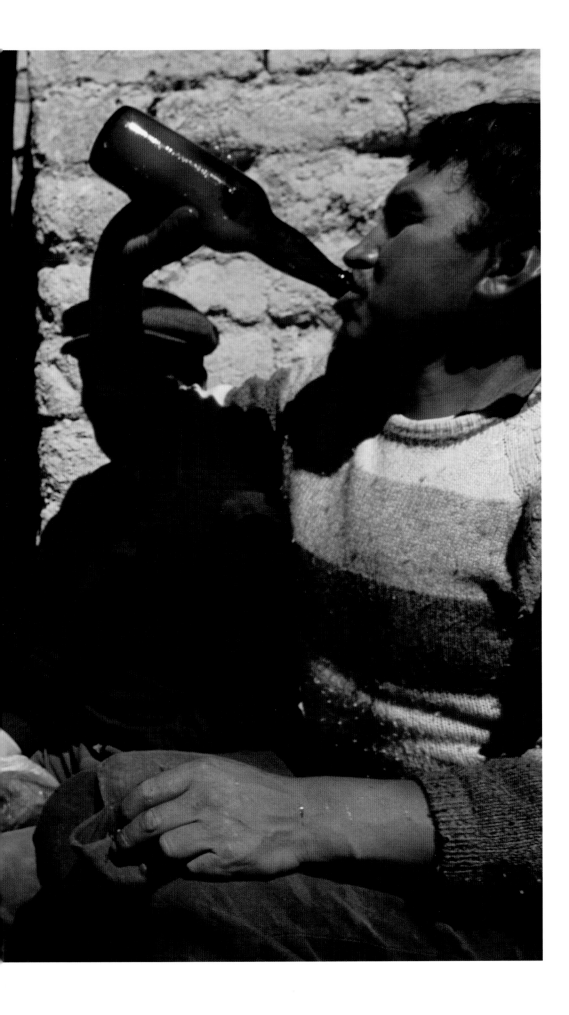

Caracoles.

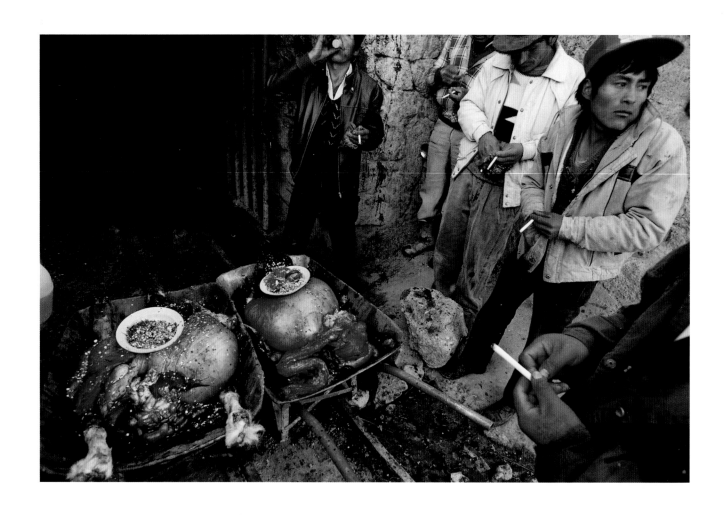

Offering, Caracoles.

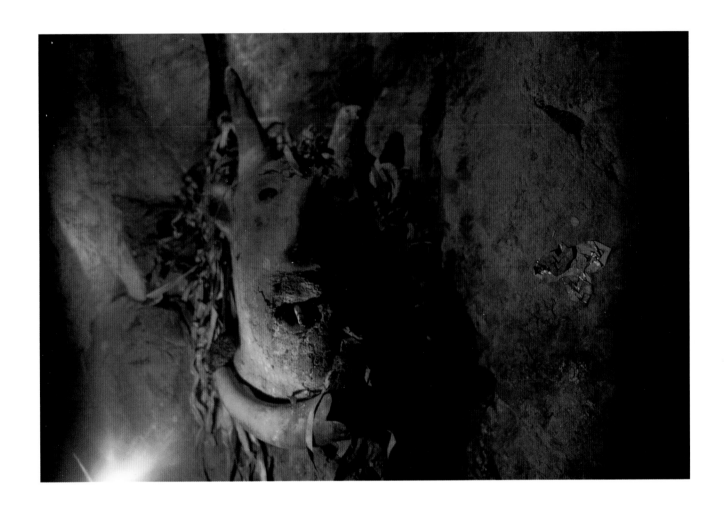

The Tío, third level, Rosario Bajo mine.

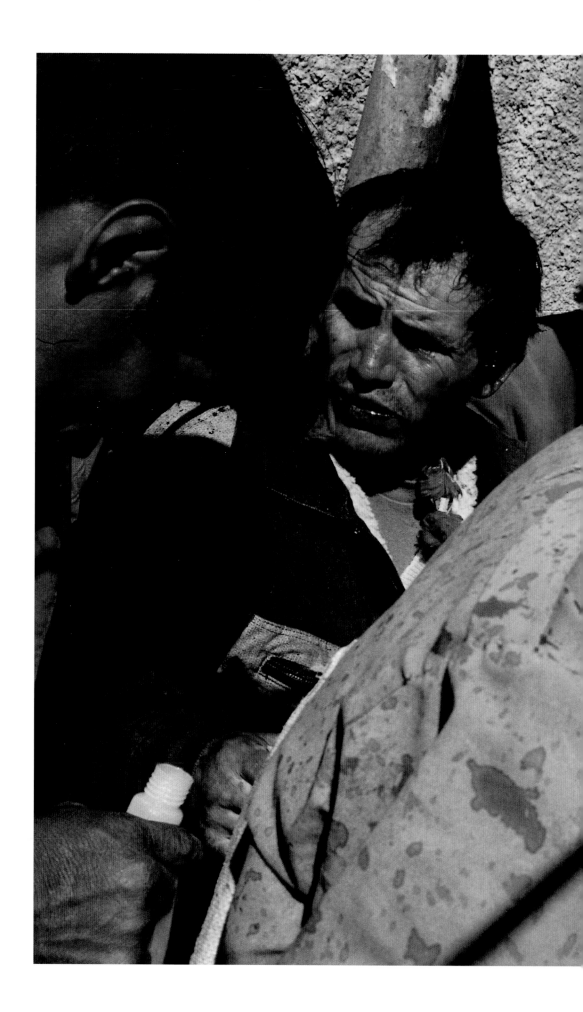

Caracoles.

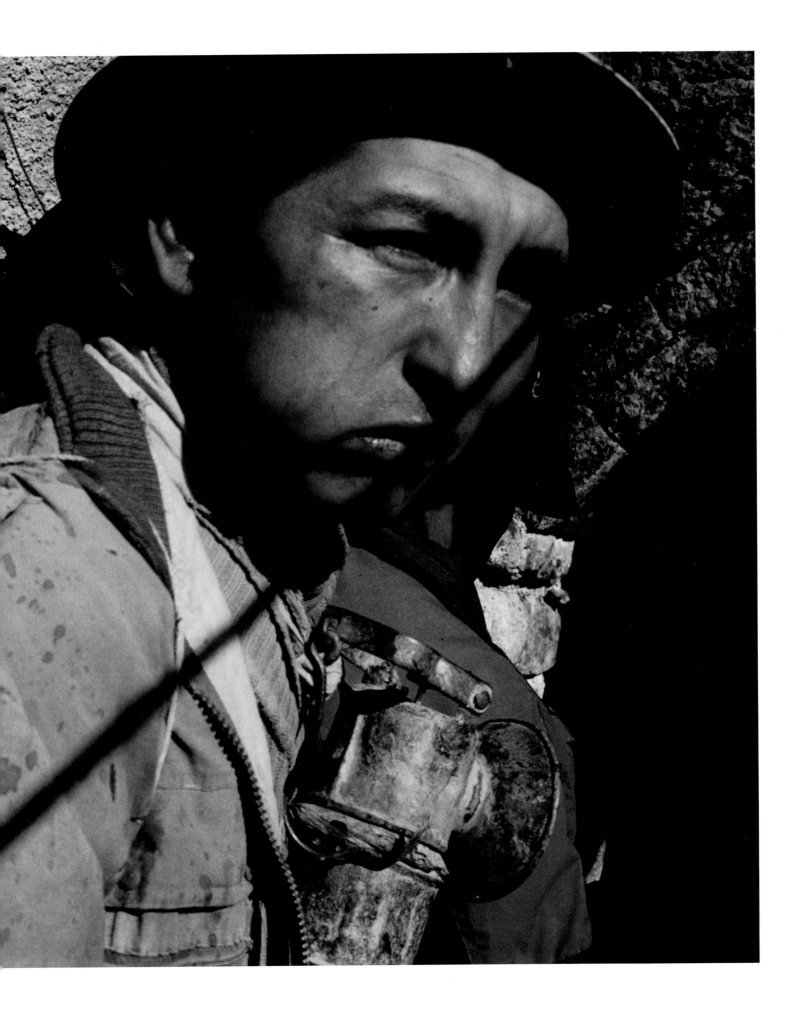

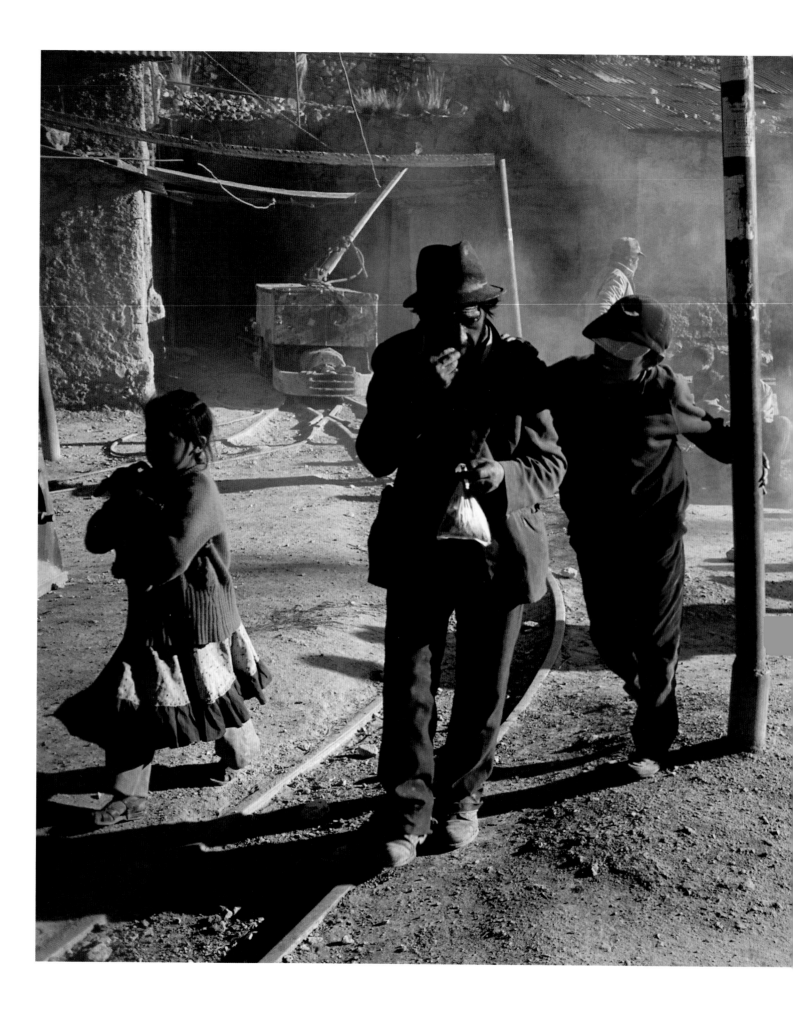

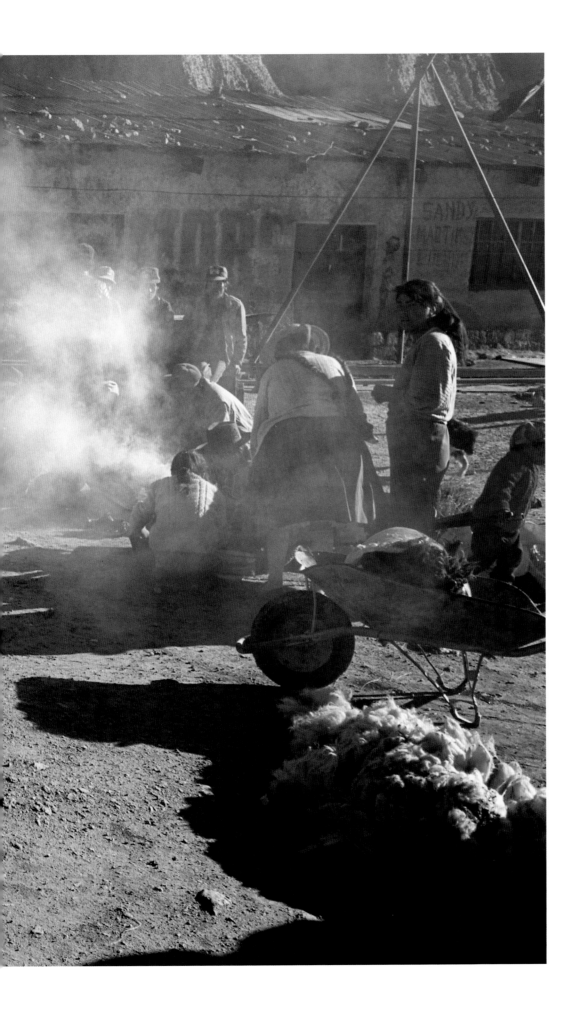

Caracoles.

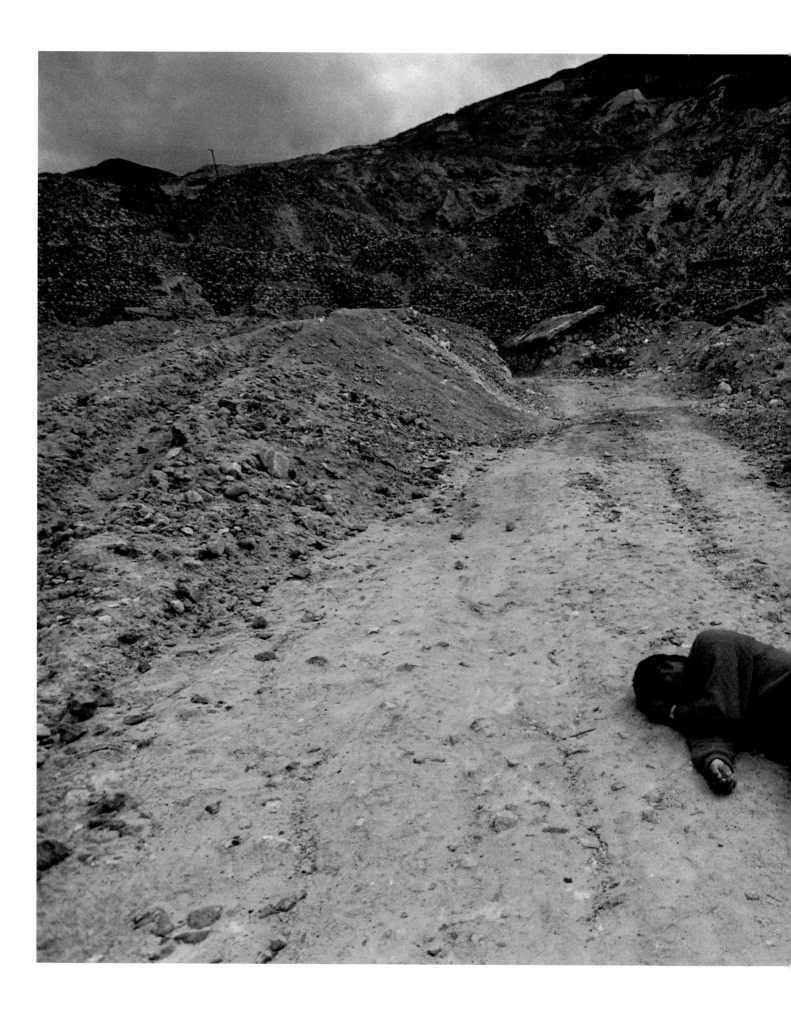

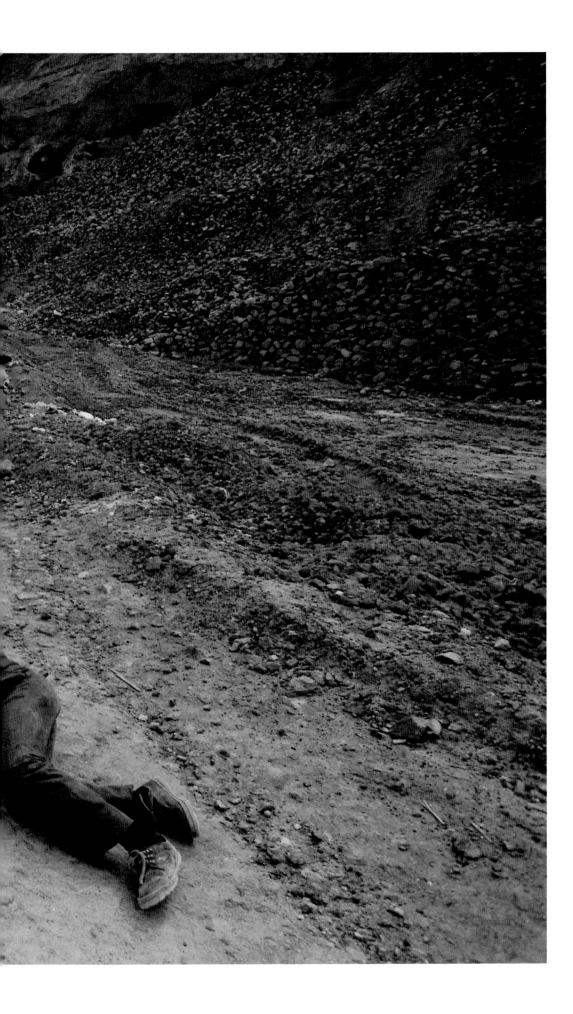

Espíritu festival.

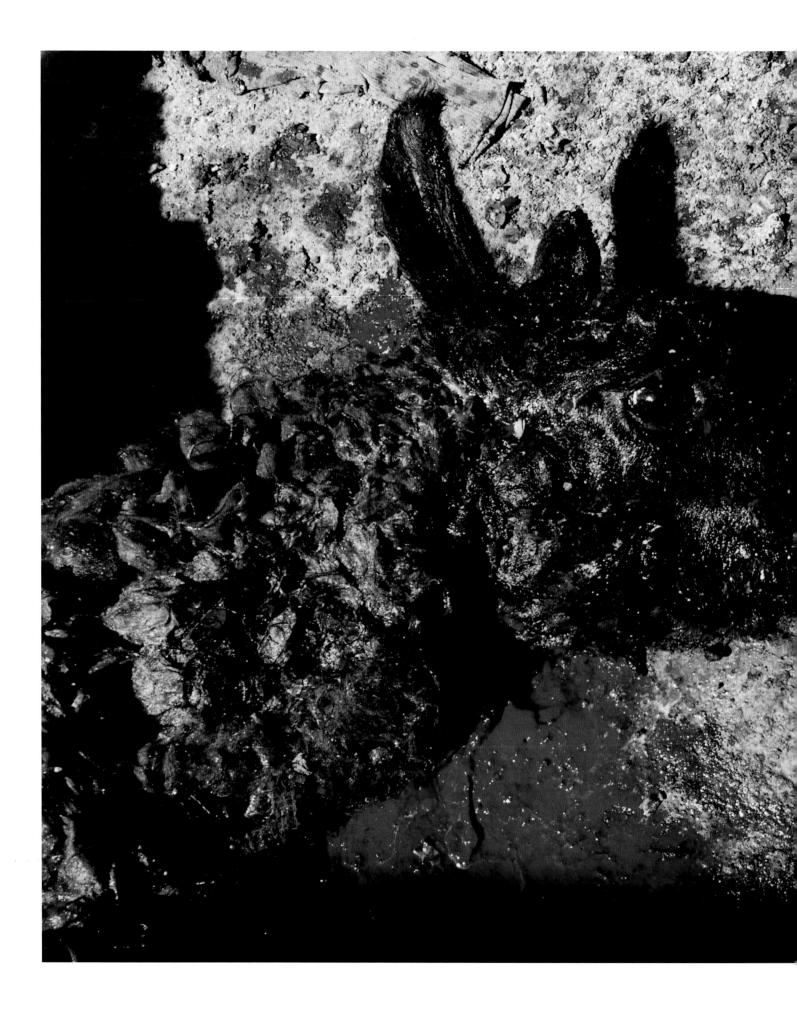

Espíritu festival.

Potosí Journal

AUGUST 19–SEPTEMBER 8, 1998

Wednesday, August 19 On the Sucre-Potosí bus, the last leg of a three-day trip from New York, I felt no excitement at the prospect of returning to Potosí. From time to time I looked out of the window and noticed the Rich Mountain—the majestic Cerro Rico—grow larger as we crossed the highland Bolivian desert and approached Potosí. But not even the sight of that great pyramid looming over the horizon could summon my enthusiasm. Somewhere inside I knew this apathy was just a symptom of *soroche*, altitude sickness, and that deep down I still cared. But mostly, I felt a profound fatigue.

The city of Potosí is 13,780 feet above sea level; the mountain rises another 1,900 feet or so above it. Accustomed to living at sea level in New York, I always suffer the first days. The only recourse is coca leaf, which is used by every miner in Potosí to work at these heights. It is chewed along with a catalyst, *lejia*, which comes either baked hard in ashes and potato or mushed up with sweet plantain and seasoned with anise seeds. Ingested in this form, coca won't get you high, but it does boost your respiratory system and it dulls pain. The consequences of failing to chew coca at this altitude are unpleasant indeed: violent bouts of nausea; bone weariness; headaches that would scare an anvil; nosebleeds; depression.

I checked into the Hostal Colonial and went immediately to the market for some coca and then to the main square. About an hour of light remained. A ceremony was taking place for the winners of a traditional-pastry-baking contest. They were given silver-plated plaques embossed with an image of the mountain. A brass band was playing, made up of some policemen I knew from a previous trip. Potosí is virtually crime-free, so the police band is available for hire most anytime.

A miner came walking by, a little drunk, and greeted me as if we knew each other. I invited him to a piece of pastry. He hardly spoke Spanish, and I don't speak Quechua, the language of Bolivia's indigenous majority, but we were enjoying our attempt to chat. Although a number of people were standing around and sampling the confections, a middle-class man in a tweed jacket and oversized glasses soon came up and told the miner in Spanish that he should leave. The miner did not understand him, so the man began making gestures and noises like he was shooing away a dog. I am always taken aback by the frank contempt the *mestizo* (mixed blood) middle class has for the Quechua miners, whose labor keeps the city of Potosí economically alive.

Thursday, August 20 In the morning I went up to Calvario, the miners' neighborhood at the base of the mountain, and spent the early light lurking around a plaza next to the

147

little colonial church. I noticed how a nearby roof and the plastic tenting over a market stall perfectly mimicked the slopes of the mountain. Somehow, the mountain is repeated all over Potosí by harsh shadows and angles, as if the retinal memory of the pyramid were too strong to fade.

This rigorous geometry of light reflects the stark facts of Potosí. Lives here are determined by precise gramweights of minerals; the population swells and shrinks in strict relation to quotes from the London Metals Exchange; silicosis destroys the lungs after a certain number of breaths take in enough particles of rock. The Spaniards made precise distinctions between categories of Indians and noted exact degrees of racial mixture among the creoles. Shortly after sunrise, the exposure reaches $1/250$ second at f/11.7 and stays right there until sunset. The mountain and its metals are physics, and physics reduces to math. There is no margin for sentimentality.

In Calvario, I ran into my friend Bernabé Mamani. He seemed less wasted than when I last saw him, but he had a haunted look in his eyes that made me fear his silicosis had gotten worse. I asked him if he had made *socio* in his mining cooperative; when I saw him last he was trying to work his way out of *peon* status. *Peons* are day laborers with no rights; they earn between $5 and $15 a day, depending on their age and skills. The *socios* earn about $20 a day and have a "voice and vote" in the cooperative, plus a little health insurance. "*Socio, socio,*" he affirmed.

I also saw Doña Valentina Puita Contreras. She has five children, tuberculosis, and a little stand where she sells oranges and coca. She looked relatively well, although she told me her husband left two years ago, shortly after the birth of her most recent child, María Anjélica. Her three youngest kids were all over me; they particularly liked my beard, which Andean men don't grow. Doña Valentina asked if I would like to be María Anjélica's godfather. I was delighted by the offer, and we made a plan to meet the next week during the pilgrimage to La Puerta and have María Anjélica baptized there. Meanwhile, I was responsible for getting her a little white outfit for the service and another dress to change into afterward.

I then went up to the Caracoles mineshaft. Caracoles is about two-thirds of the way up the mountain, on the western flank that faces the city. When I got there at 9:30, the miners were still chewing, or *pijcheando,* their coca leaf. They tend to sit for almost an hour talking and filling up their cheeks in preparation for entering the mine. I came equipped with a bag of coca to share around.

I tried to make small talk by remarking that fake Nike caps are all the rage now among the miners; I mentioned that I even saw one with a marijuana leaf sewed over the Nike swoosh. A miner grumbled that I was going to portray them as drug addicts and traffickers. In Potosí, no one smokes marijuana, and they disdain cocaine, seeing it as vulgar and unnecessary. In fact, the larger leaves from the Chapare region, which are higher in alkaloid content and used as the base for cocaine, are the cheapest and least preferred here. In 1997 and 1998, the United States gave Bolivia $82 million for coca eradication, and U.S. drug-war policies are heavily debated in the Bolivian media. Many miners see the drug war as an attack on their ancient customs.

Walking downhill, I came upon four *palliris* at work breaking rocks. The word comes from the Aymara language, meaning "to choose." *Palliris*, the widows of miners, have the dubious privilege of picking through discarded mine tailings on the surface of the mountain. They spend their days outside, breaking rocks with a small hammer, seeking out bits of tin, silver, and zinc, which they put in bags and haul down to sell at the bottom of the hill. The *palliris* of Potosí eke out a miserable living that amounts to $10 a week or less. Their situation has gotten worse in the last few years—the Comcur mining company, owned by Bolivia's last president, Gonzales Sánchez de Lozada, has trucked off most of the surface tailings for industrial processing.

The women received me and my coca leaf amiably. As we chewed, they told me that if you don't *pijchear* coca on the mountain, the Pachamama (earth goddess) will suck your blood, you'll feel heavy, and you won't be able to move. At that very moment my nose started to bleed copiously and I had to lie down.

We were soon joined by a miner who

emerged from a nearby *bocamina*. He introduced himself as Don Eusebio Barra Seco and told the women that he had recently seen tourists going into a nearby mine. "In their countries, they have airplanes and machinery, but they don't pay hardly anything to take pictures of us." I agreed with him. I once accompanied a group of European tourists into the Candelaria Baja mineshaft, and it was an ugly experience. The tourists took snapshots and rolled video of some teenage *peons* doing backbreaking work, gave them some coca leaf, and left to go see the cathedral. I imagined the miners must have felt like a "Quechua Miner" diorama in a museum.

Friday, August 21 I went briefly into the Candelaria Baja mineshaft with Don Bernabé. It was stifling and claustrophobic. Once again I felt the tension of not knowing when a rock-laden wagon might hurtle out of the darkness or where to be careful not to fall in a deep hole. I had to stop many times to gasp for breath, asphyxiated by the altitude and the lack of oxygen in the mine. We continued, hunched over, to his workplace. Every so often, I glimpsed the viscous purple and green ooze that seeped from the walls and ceilings, which sometimes forms stalactites and stalagmites. The miners tell me it is arsenic and sulfuric acid; the water underfoot can be so acidic that I have to be careful where I place the legs of my metal tripod. The greatest danger in the mine is the release of these chemicals by an explosion. When a dynamite placer is killed, it is more often from the gas than from flying shards of rock.

But the mine also has its sensual side. Apart from the small carbon lamps and the miners' electric headlamps, there is no light. Apart from our voices and breath, the clanking of metal and rocks, and the occasional muffled boom of dynamite, there is no sound. The mine can be deafeningly loud or completely silent. At one point, I turned my Maglite off and walked around a corner. Utter darkness. Total silence. In this spot the air was cool, and strangely comfortable.

Saturday, August 22 The mass for San Bartolomé, which begins the Ch'utillos week, took place this morning down by the cemetery. The Ch'utillos festival and the upcoming pilgrimage to La Puerta are held in honor of San Bartolomé, to commemorate his victory over the demon of La Puerta. San Bartolomé's triumph in 1589 marked an important step in the growth of the early colony, because it secured the road from Potosí to Cuzco. As told by the historian Martínez y Vela in the beginning of the eighteenth century, this demon was trouble indeed: "Sometimes when people passed through the gorge, the two hills, which are very high, came together, killing them and then opened again … Other times, a hurricane wind would spring up, so frightening that it would take their lives immediately, and if not immediately it would dash them on the rocks."

As part of this morning's mass, participants in Ch'utillos solemnly promised the saint that they would dance their hearts out. Today was also the big rehearsal day, so by afternoon a carnival atmosphere had spread throughout town. The streets were filled with young people dancing their hearts out. Teenage girls, usually nothing but chaste, flung their hips around provocatively and flirted with the admiring crowds. Around midnight, I came on the marvelous sight of a group of ten-year-old boys, in fedoras and suits, leading a brass band in a gleeful dance around the plaza.

Sunday, August 23 I woke up with a headache, feeling guilty because I had planned to photograph several masses this morning. I made it down to the Confitería Alemania on the corner, where I knew I would find hot chocolate and soup. My friend Oscar Medina was there; he introduced me to Jorge Gutierrez, with whom he had just started a tourist agency. Perhaps sensing my distaste for the tourism here, Jorge quickly said that their agency hoped to be different from the others, and that he had a plan to use tourist revenue to help the miners get medical care.

Don Jorge wants the mining cooperatives to demand a higher percentage of the fees tourists pay to visit the mines and use it to set

up a fund for a clinic. Tourism is growing in Potosí, and he thinks the plan could work. His interest is partly to gain an edge over the other guides by helping the miners. But I can see that as a former miner himself, Jorge is indignant about the situation.

And for good reason. There are no medical facilities on the mountain. The *socios* are insured and can go to the Caja Nacional Hospital in town, but the *peons*—the majority of miners—are not. Doctors at the Caja Hospital report that 90 percent of the miners have silicosis, and of those at least 80 percent also have tuberculosis. The average miner succumbs to these illnesses around the age of forty-two, spending his last months coughing up blood. Accidents in the mines are frequent, and there are usually no vehicles to transport the victims to the hospital.

Monday, August 24

Just before we got to La Puerta, about forty kilometers from Potosí, our driver pointed out a cave in the hills above, closed in with bars. It is there that San Bartolomé imprisoned the demon. La Puerta itself consists of two churches, a school, an enormous plaza, and a cluster of houses beneath huge cliffs. The plaza filled up early with pilgrims and people setting up stalls to hawk their wares.

At 10:00 A.M., Doña Valentina, María Anjélica, and I attended the baptism in the schoolhouse, which was conducted by a tall Spanish priest in his sixties. Along with his vestments he wore a floppy camouflage hat. There were about forty families there. For some reason, when the priest saw my cameras he declared that "Photographers work with the devil."

After the ceremony we celebrated, further bewildering María Anjélica by pouring beer on her head. Custom has it that the mother buys the rounds, which were numerous, and the lunch, which was a delicious spicy potato and llama dish. When we left at nightfall, the bacchanal was in full swing. Children were guiding their fathers by the arm, couples sprawled on the ground, and from all sides brass bands played the same song over and over.

Tuesday, August 25

I hired a car to take me back to La Puerta, hoping to find

interesting images of the morning after. The chapel was almost empty, except for the caretakers, who were scraping off the wax stuck to the floor and pews from yesterday's prayers. A few people were asleep. San Bartolomé still stood vigilant against the devil, even after the excesses of the previous night.

Several worshippers approached the statue to kiss the hems of his garment; they held up trays of incense and devoutly blew the smoke at the saint. I took a picture or two with flash—and immediately regretted it. I had used it to clarify the scene, as if explaining things to my imagined readers were more important than the murky truth. And though I had minimized the flash, the bursts of light changed the mood and disturbed the devoted. I thought of a phrase attributed to Henri-Cartier Bresson: "Using flash is like firing off a cannonball in a cathedral."

Wednesday, August 26

Today, the Unificada Cooperative celebrated its forty-fourth birthday. At 10:00 A.M., there was a mass in honor of the dead at the Unificada mausoleum. The priest, who seemed to be from a mining family himself, stressed social justice and education in his sermon: "We must have faith with both hands, the Bible in one and a newspaper in the other." Little boys waited in the wings, hoping to be contracted to clean the niches of the dead. Some of these niches have fancy glass covers, but most are simply holes in the mausoleum wall containing a coffin, with perhaps a Nestle powdered-milk can holding flowers. Most of the flowers were fresh—widows usually come on Monday afternoons, "the day of the souls," to sit and chew coca with their deceased husbands.

In 1952, Bolivia underwent an extraordinary workers' revolution, led by the miners. The new state nationalized the mines and began to protect and subsidize the tin industry through the Bolivian Mining Corporation (COMIBOL). At its height, Pailaviri, the COMIBOL mine in Potosí, employed some six thousand men, who enjoyed an array of benefits: sick days, overtime pay, subsidized stores and housing, and a modest salary. The miners of the cooperatives, by contrast, earn according to what they

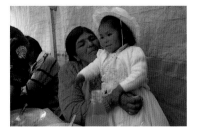

extract, less about 12 percent that goes to the cooperative for social security, to the state for leasing the ground they work, and to a few other charges. The cooperativists sometimes refer to COMIBOL workers as the "miners of the fat bread." Jorge Gutierrez (who agreed to be my Quechua translator) said they "only show up to collect their salaries. They have no energy in their faces."

Once the silver deposits were for the most part exhausted, tin became, for much of the twentieth century, Bolivia's major export product. But in the mid-1980s, a crisis hit the tin industry. The United States released its enormous strategic reserve of tin onto the world market; other substances began replacing tin in industrial uses; and large tin deposits were found in Brazil and Malaysia. By 1991, there were only about six hundred workers in Pailaviri, and by 1995, the neo-liberal government of President Sánchez de Lozada closed the mine and put it up for sale. The cooperative miners now outnumber state miners throughout Bolivia.

Two years ago, just after COMIBOL signed a contract with a Peruvian company to reopen the Pailaviri mine, workers from several Unificada Cooperative sections took over parts of it. They posted guards armed with the miners' traditional weapon, dynamite, and began working twenty-four-hour shifts. This action harkened back to the violent days of the early 1980s, when Potosí and Oruro, to the northwest, were the sites of desperate strikes against Bolivia's dictatorships, which were among Latin America's most repressive. The army often surrounded the mines, and many union leaders were killed or disappeared. Miners wanted by the security forces literally went underground, hiding for months in the tunnels. Fortunately, Bolivia, like the rest of South America, has recently entered a more democratic phase, and the Unificada miners won the right to work some Pailaviri galleries without bloodshed.

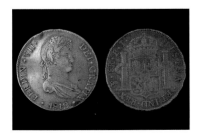

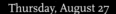
Thursday, August 27 I jumped on a bus headed to the mines. On board I saw a miner seated next to his son, who appeared to be around eight. Quite a few children this age

work in the mines after November, when school is out, but a few enter now with their fathers. "Nobody can tell a miner not to bring his son in," Jorge had told me. Fourteen- and fifteen-year-olds are common throughout the year, usually working as *cargadores*, hauling the rock-laden cars around. I asked the miner, Don Armando, if I could accompany them to the mine. The three of us walked through the spectacular landscape overlooking the city. Once at the San Jacinto mine, we talked and chewed with the other miners. Don Armando gave his son his first mouthful of coca, which the boy handled with studied nonchalance.

As it happened, Don Armando was just taking him up for the day to show him where he works. "I will never let him work in the mine," he said. "He must study so he can defend himself in this world. The mine is too dangerous; we risk our lives every day. At any moment we can die."

My *comadre*, Doña Valentina, feels the same way about her sons. Her father and her first husband died in their forties; her second husband took off after María Anjélica's birth. "I just cannot do it. My father took three years to die. My first husband four months. He drank on Saturdays, Sundays, Mondays, Tuesdays, Wednesdays, Thursdays, and Fridays. The alcohol ate away his insides. No more mines. My sons will have to study."

Earlier this week, I noticed a young woman with a briefcase at the Caracoles mine; she looked strange walking around the mouth of the mine in business clothes. I asked her why she went up the mountain. A twenty-seven-year-old encyclopedia salesperson, she does a healthy business with the miners, despite the huge investment a $55 atlas represents to a man feeding six people on $75 a week. "They want the books for their children." She is the only one in her company, she said, who ever thought of selling to them.

But no matter how many miners break their backs so their sons will not have to work underground, there will never be a shortage of youngsters desperate enough to work for $5 a day. Three thirteen-year-olds I spoke with in the Santa Rita mine said they could join their fathers as construction laborers above ground, but the pay, $3 a day, was not enough. "And in

the mine you are learning a trade." The city air is filled with the cries of boys who call out destinations and collect fares on the buses. Last night, my dinner at a popular chicken place was served by an eight-year-old waitress, all got up in Pollo Speedo's fancy uniform. The cemetery, too, is another important job site; many small boys work for coins, cleaning graves and reciting prayers during funerals.

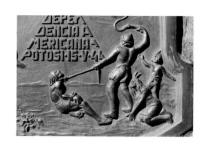

Friday, August 28

Jorge and I sat with the devil, or Tío, of Rosario Bajo. The Tío is a potent symbol of the miners' life and history, and the center of their religious life. I felt settled in his cave, somehow accepted back in Potosí because I was paying homage to this figure who embodies the essence of the Cerro Rico. We offered him cigarettes and coca leaf and talked a long while under his scary gaze. This devil, also named Jorge (after some long-departed miner), is frightful indeed. Sculpted out of clay, he has tremendous horns, around one of which is coiled a snake, a Quechuan symbol of good luck. Bearded like a Spaniard, his mouth is ever open for cigarettes, which he smokes with evident pleasure. The miners, who offer him cigarettes, coca leaf, and his preferred drink of grain alcohol, like to call him *viciado,* full of vices. He enjoys being insulted, so at times they cuss him out roundly. Tío Jorge also boasts an enormous erect penis. He wears leather knee protectors and rubber miners' boots. He is at once comrade and lord, protector and destroyer of the miners.

The anthropological literature on the Tío is varied. He is generally understood to derive from the pre-Columbian deity Supay. Some say that his cult was promoted by the Spanish to terrify the Indians into working, while others argue that the Tío was repressed by the Christian authorities. Clearly, it is wrong to view this devil as evil in the Christian sense, since Andean religion has different concepts of sin and morality. In her fascinating book *We Eat the Mines and the Mines Eat Us,* June Nash takes a Marxist view, interpreting the Tío as a symbol of the mining economy's class structure.

Certainly, the Tío manifests the miners' deeply held notion of fair exchange, of quid pro quo. Outside the mine, one should always pour a bit of drink on the ground for the earth deity, Pachamama, so the land will be fertile. Likewise, you have to offer (*chay'llar*) to the Tío if you wish to find a rich vein of mineral and stay alive to enjoy it. The rare miner who strikes it rich is always said to have offered the Tío a llama fetus, or something even more tasty. The Halevi brothers, who struck a thick vein of silver in the Encinas mine, are rumored to have thanked the Tío by paying three prostitutes $500 to enter the mine and have sex with him. They came running out, it is said, filled with terror and ecstasy. Four times a year, during the Espíritu festival, the miners pool their scarce resources to buy llamas to sacrifice to him. They adorn the mine entrance with its blood and bury the paws and entrails, neatly arrayed and covered with confetti, inside near the Tío.

Our thoughts turned to the dead. Don Jorge and I continued an earlier discussion about how many Indians may have died under the *mita,* the forced-labor system the Spanish introduced to exploit the Cerro. Jorge remarked that although the writings of Eduardo Galeano on Potosí influenced him and opened his eyes to many aspects of Latin American history, he thinks Galeano's estimate of 8 million dead is grossly exaggerated. The *mita* conscripted 13,500 males a year to work in the Cerro Rico; it lasted from the 1570s until independence in 1825—about 250 years. The number of conscripts diminished somewhat in the later years of the *mita,* but for the sake of argument we multiplied 250 by 13,500, for a total of 3.375 million *mitayos.* It is hard to know how Galeano arrives at 8 million, unless he means all the deaths indirectly caused by the *mita*—through disease, the disruption of agriculture, and other forms of culture shock.

It is reasonable to assume that between half a million and one million Quechua died directly from the *mita.* Accidents, malnutrition, and the epidemics of smallpox that spread especially quickly in the stagnant air of the mineshafts all took a major toll. But where are the remains of all these dead? The only text I have found that speaks to this point was written in 1925 by Alberto de Villegas and may have no basis in fact: "Annihilated by the endless arduous work, they were buried right there

in vast secret catacombs, of which Governors and Viceroys never spoke again." Don Jorge said he never heard a miner tell of encountering bones in the mine. Were the *mitayos* obliged to haul bodies out of the mine for burial elsewhere? Are there mass burial grounds in Potosí, or were the corpses incinerated?

Later that day, we met a veteran miner named Arnoldo Al-Cazar up at the San Germán mine entrance. At fifty-two, he is one of the oldest men still active on the Cerro. We asked him if he had ever heard of anyone finding bones. He replied, "No, but my cousin left a few inside. He died in a cave-in, and in order to get his body out, some comrades had to cut him in quarters. His arm and shoulder are still in there somewhere."

Sunday, August 30

Ch'utillos was celebrated today with more dances, including three that relate to the history of Potosí: the Diablada, the Morenada, and Caporales. The Diablada is danced by at least a dozen men wearing ornate costumes and masks representing the devil. They are accompanied by one or two she-devils in miniskirts and red tights, who look more kittenish than diabolical. These latter are said to represent the China Supay, or wife of the Tío, but it is confusing because some evidence suggests that originally this dance derives from Christian, rather than Andean, roots. Of course, the dance could well syncretize both traditions. The troupe is led by the archangel Michael, in a blue cape and tights, who holds a sword ready to cut sins into bits.

The Morenada, or dance of the brown ones, represents African slaves brought to the Andes by the Spanish. The dancers wear shiny barrel-like costumes tiered in the manner of a wedding cake. According to June Nash, the outfits represent the casks that held the wine stomped by slaves. (During the colonial period, the Africans could not withstand the altitude and perished quickly in the mines, so they were put to other tasks.) The dancers twirl a *matraca*, which makes a rasping noise representing the clanking of chains.

Caporales features dancers wearing shiny, luxurious suits with high boots. They make whipping motions as they go, because they

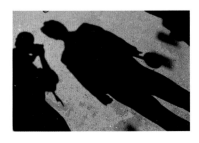

represent the Spanish foremen who oversaw the labor of the *mitayos* in the mines.

Monday, August 31

We went up to Santa Rita to take part in a *chay'lla* with an old acquaintance named (appropriately) Don Fausto. As we sat in the devil's cave, the miners got into a theological discussion over the nature of the Tío, which Don Jorge translated for me. Don Fausto told the story of God expelling the archangel Lucifer from heaven, and Lucifer making the underworld his kingdom. "And that is why the miners worship him, because even though he was the black sheep of his family, he still managed to become a lord." This was the first time I had heard a Christian take on the Tío. Another miner disagreed with this version, saying that the Tío dated from "the time of our ancestors," from the deity Supay, and that he should not be mixed up with Catholicism.

Indeed, Tío worship is not a syncretic belief system. The miners consider themselves Catholics outside the mine and will often put a statue of Jesus (Tata Kh'akju) at the mouth of the mine. Once inside, though, they switch to the Tío. The miners will not utter the names of God, Jesus, or Mary in the mine, for fear of offending him; some will not even use a pick inside the mine, because it is shaped like a cross.

Wednesday, September 2

I went to the most active work site in the Rosario Bajo mineshaft, at the intersection of two sets of rails. A group of zinc miners was unloading small cars here, then shoveling the contents into larger wagons to be dragged out of the mine. At the same time, another group was using these rails to move cars loaded with low-grade silver-tin complex.

When I first came to the Cerro Rico, in 1991 and 1992, the price of tin still made it worthwhile to mine. Because it runs in purer veins and is easier to get at, tin can be mined by just one or two workers. By contrast, zinc and silver-tin complex require groups of four or more. These teams share the expenses of their particular area, such as hiring *peons*. But no one takes responsibility for common areas, especially when they are shared not only among groups

but among mineshafts as well. As a result, this rail crossing was in total disrepair and wagons frequently jumped the tracks.

I stood and watched. The atmosphere at the crossing was tense, and it would have been stupid to take pictures. The silver-tin miners, who are said to make the most money of the groups in Rosario Bajo, were working with a vengeance. Such was their haste to roll their cars out of the mine that when they found the way blocked by a derailed zinc car, they became aggressive. Fourteen angry men were pushing loaded carts back and forth, hastily trying to jack up the derailed one with a log and shouting at each other. I was sure someone's leg would get crushed. Nobody was hurt, but they almost came to blows, at one point threatening to beat each other with shovels.

Thursday, September 3 Don Jorge and I met with the leaders of the union section at the Rosario Bajo opening, because they said they wanted to discuss Jorge's ideas about health care. But they were too drunk to have a serious meeting. I gave out the photographs that I had taken at the Unificada anniversary party, and we toasted one another many times. Ch'utillos week is not the time for political organizing.

Friday, September 4 The Lung, where the Rosario Bajo and Candelaria Baja sections share a vein of zinc, is deep underground. A small cave at the intersection of two tunnels, it gets its name from the gas leaching out of the walls. I couldn't see any vapor, but fifteen minutes later I was trembling and felt like blacking out. Noticing my state, a miner running the primitive winch said "This is nothing" and pointed down the narrow vertical shaft that links the two levels of the Lung. As we watched another miner carefully grope his way down, seeking out dubious hand- and footholds in the colonial-era stone tube, he added simply, "It's dangerous." Four men worked down on the lower level, filling up an onion-bulb of a rubber sack that was then winched up to three others who gruntingly wrestled with it until the zinc loam spilled out, which two workers shoveled into an iron car. As soon as the car was full, the three youngest pushed and pulled it almost a kilometer to the outside world. The older miners ordered one of the shovelers—a fourteen-year-old *peon* named Sebastián—to go down to where the fumes came from and help out, but he refused. He seemed ill from the gas. When we got out at 6:30 P.M., the miners still had hours to go. They had been in there since morning, while I had one of the most terrible headaches of my life.

Saturday, September 5 Don Jorge and I explored the wild landscape on the western side of the Cerro, along the road between the Caracoles and San Jacinto mine openings. We drove up in Jorge's enormous blue-and-white Toyota, passing a number of *bocaminas* I didn't recognize. Jorge recited their names: *La Morena*, the Brown Woman; *Grito de Piedra*, Shout of Stone; *Porvenir*, Future. The topography of the Cerro is so complex that whole camps are hidden behind strange escarpments or tucked into unexpected valleys. In the distance, we could see miners leaning against pillars of rocks or seated on a perilous outcropping, having their morning *pijcheo* of coca leaf.

Sunday, September 6 The light was strange today. The sky looked like a gunmetal sheet, or a poor-quality X ray. The Cerro itself seemed recessed, a relic displayed behind smeared glass in some neglected museum. The weatherman on the radio described the conditions as "entirely negative."

The drop in temperature reminded me of fall in New York. The light at this time of year is clear. As the days cool and the molecules slow, it becomes easier to see and to think. But here it is not autumn, nor are there any trees to shed leaves. In the last essay of *The Soccer War*, the journalist Ryszard Kapuściński tells of sitting one night by a campfire in the jungle with Ghanaian village elders, sometime late in December. He wants to make himself known to his hosts. Yet how to tell them of his longing for the mood of snow and trolley cars? How can a journalist ever explain one people to another when even the elements emphasize difference?

The highlands of Peru and Bolivia (the *alti-*

plano) have always been a region of travelers. The Incan empire was built on a complex system of exchange between ecosystems. To ensure balanced trade, clan groups contained families in both the highlands and the lowlands, which meant a lot of travel between areas. When people meet me in Potosí, they often ask the same three questions: "When did you get here?" "When do you leave?" "Are you traveling alone?" Ancient courtesies. A few days ago, after such queries, a *palliri* jumped up and came over to me, exclaiming, "Ay, poor little one." She pitied me for being on my own so far from home.

Monday, September 7 Don Jorge and I returned to the Santa Elena *bocamina* to visit my friend Doña Sinforosa Fita Morales and her daughter, Sandra. I could see Doña Sinforosa's pink hat ribbon from way above, and she waved us down to the cluster of straw-roofed stone huts that make up the camp.

Doña Sinforosa and Sandra share a room measuring no more than four by six feet, pitch dark except for a trickle of light that follows the cold in through cracks. One half of the room is occupied by a narrow, tumble-down bed; their few garments hang from nails. Plastic bags form a divider for the "dining room," which has a table made from a cable spool and a box that is used as a seat. From here, Doña Sinforosa can look out and see what needs to be done around the mouth of the mine.

Another curtain of plastic separates the little kitchen where they make breakfast for the miners. Through a hole cut in the wall they pass the soup into a bright room with some soccer trophies, the mine's Tata Kh'akju, and a table. The soup, chicken broth with lots of noodles and hunks of potatoes, is welcome after climbing in the bitter morning wind. But more important, it is fuel, loaded with the carbohydrates that will allow a miner to work for many hours at a stretch without eating again.

Tuesday, September 8 All the mineshafts are closed today, in honor of the Fifteenth Ordinary Congress of the Cooperative Miners of Bolivia, which is being held in Potosí. The march of the cooperative miners started around two and led from the Plaza del Minero, in Calvario, to the cooperative meeting place downtown. The mining cooperatives were grouped behind their standards: Unificada, Villa Imperial, Real Potosí, Compotosí, 12 de Noviembre, and a host of others from small mines in the north of Potosí and elsewhere in Bolivia. As they waited to get started, union officials walked up the street greeting local leaders with affectionate embraces. The mass of miners was boisterous and unruly. One leader asked me mock-challengingly why I was taking pictures, and I teased, "To show how orderly your columns are." He retorted, "Only the army should march in straight lines."

The marchers were in a good mood, joking and eating popsicles. Delegates from the different mineshafts held aloft their nylon tricolor standards, which glinted in the afternoon sun. Looking around at the people gathered to watch, I could see pride on their faces. Housewives and shopkeepers waved at the passing throng from their doorways. The miners paraded by the plaza and the cathedral, the colonial mint and the covered market, and continued downhill toward the Four-Hundredth Anniversary auditorium. Throughout the march, the Cerro Rico was visible in the background, a perfect triangle etched against the blue sky.

As I watched the miners enjoying this rare afternoon in the sun, I thought about how they have sacrificed their health to their work, and about their courage. How many of these marchers will be alive in five years? In one year? I thought of the time I asked a miner in the Lung how he put up with those fumes day after day. He answered, "We simply have a tremendous will to feed our families." Ever since the arrival of the Spanish in 1545, the Cerro Rico has demanded a bloody sacrifice before it yields its metals. So each day these men go into the mouth of the mountain and offer up their lives. They let themselves be devoured by the Cerro Rico in the hope that it will spare their children.

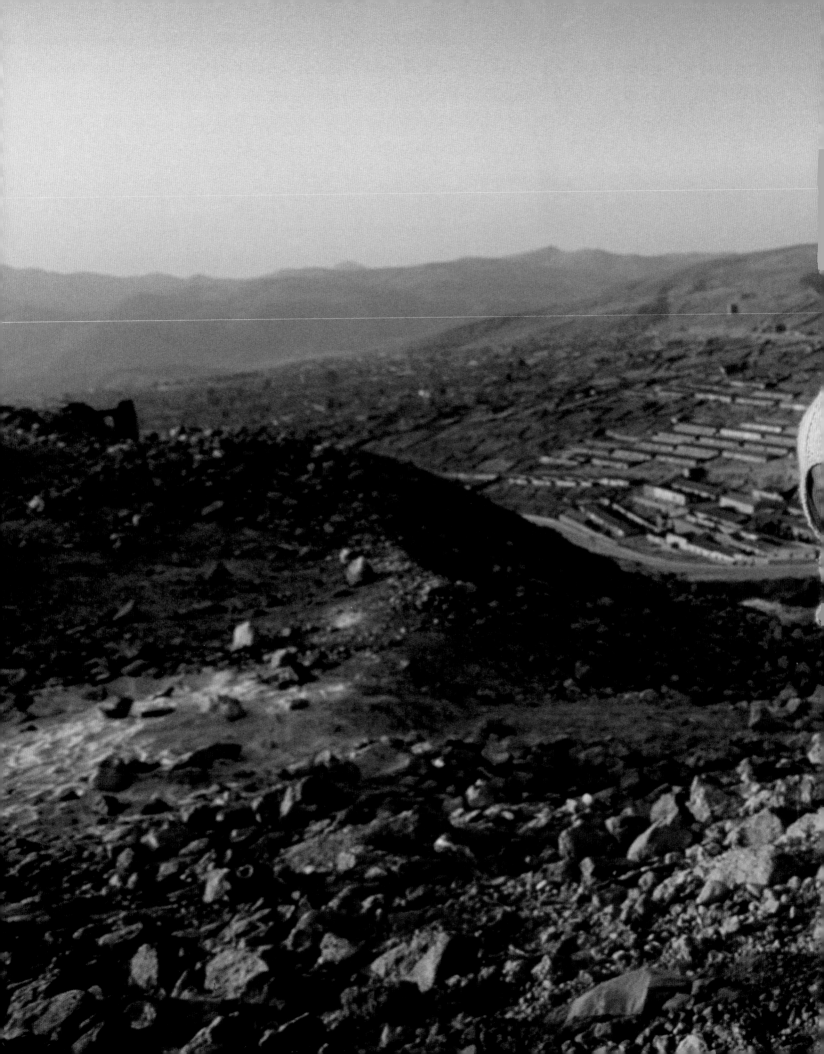

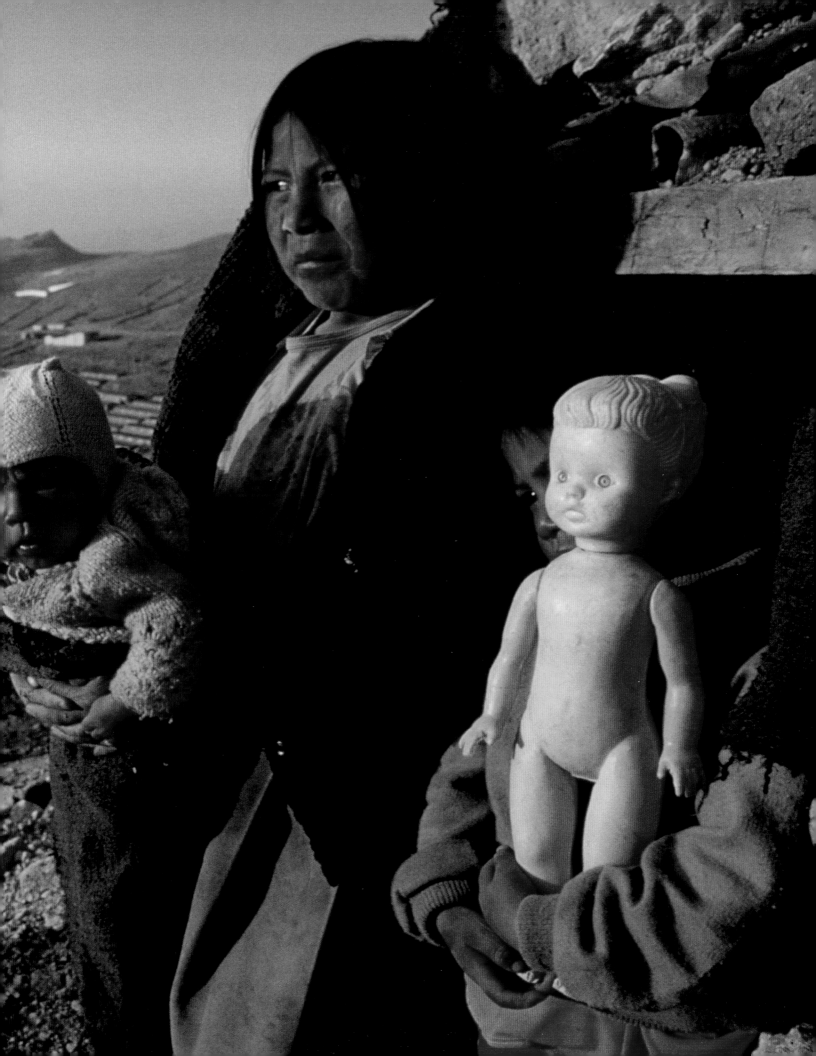

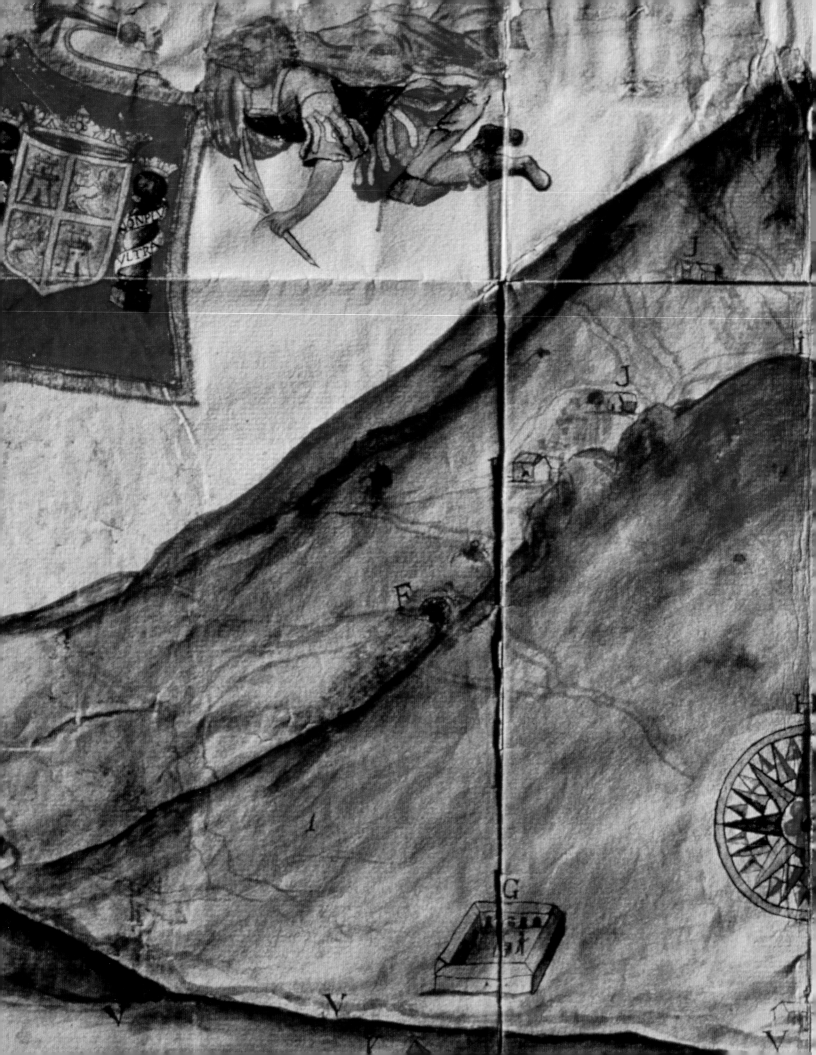

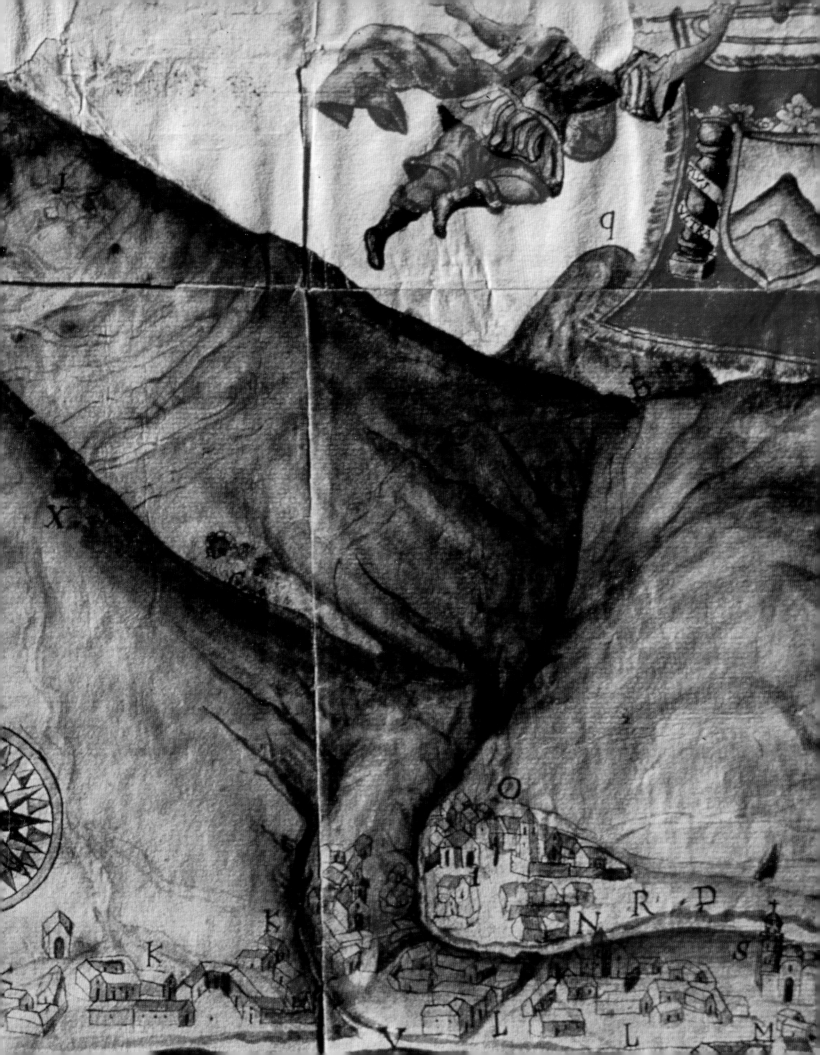